Painting
Wild Landscapes
in Watercolour

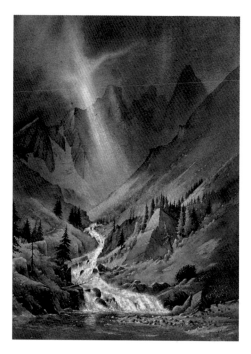

DAVID BELLAMY

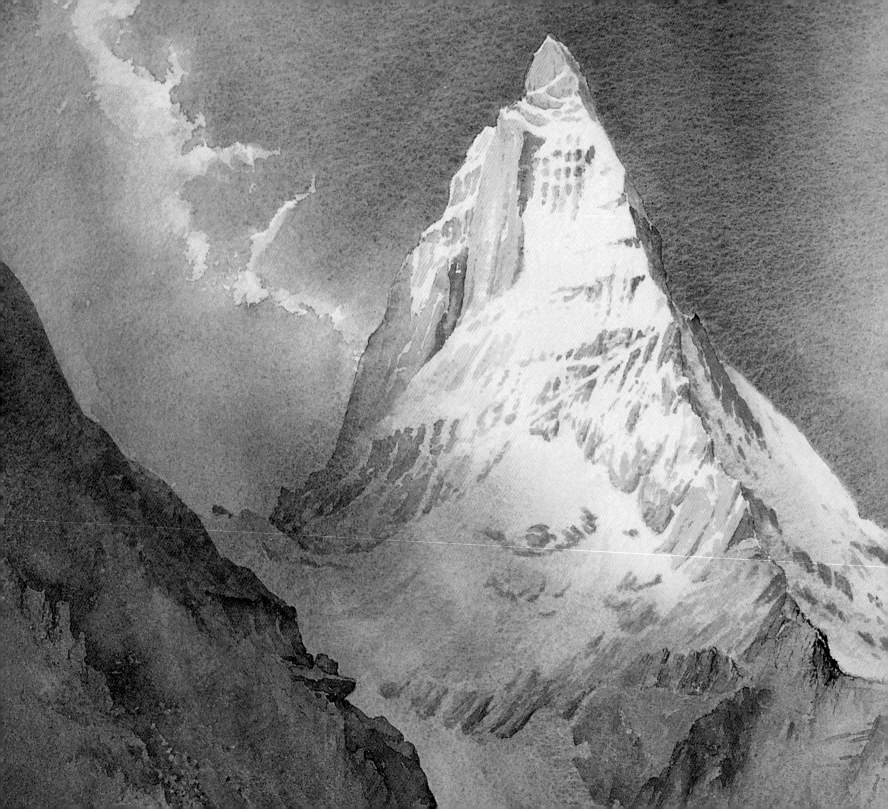

Painting
Wild Landscapes
in Watercolour

DAVID BELLAMY

Collins

To the mountain peoples

Acknowledgements:

I would like to thank Jenny Keal for checking the manuscript and other tasks on this book,
and Cathy Gosling at HarperCollins who is always so encouraging.
Thanks also to Helen Hutton, Geraldine Christy and Anita Ruddell.

Photo credits:

Jenny Keal for photos on pages 8, 38, 96, 108; Catherine Bellamy on page 72; other photographs by
David Bellamy

DVDs and Videos:

DVDs and videos on watercolour painting by David Bellamy, including one entitled
Painting Wild Landscapes in Watercolour, are available from:
APV Films, 6 Alexandra Square, Chipping Norton, Oxfordshire OX7 5HL (Tel. 01608 641798)

Website:

David Bellamy's website address is www.davidbellamy.co.uk

First published in 2005 by
HarperCollins*Publishers*
77-85 Fulham Palace Road
Hammersmith
London W6 8JB

The Collins website address is
www.collins.co.uk

Collins is a registered trademark of HarperCollins Publishers Limited.

03 05 07 08 06 04
2 4 6 8 10 9 7 5 3

© David Bellamy, 2005

David Bellamy asserts the moral right to be identified as the author of this work.

A catalogue record for this book is available from the British Library

ISBN 0 00 717553 1

Editor: Geraldine Christy
Designer: Anita Ruddell
Indexer: Elizabeth Wiggans

Colour origination by Colourscan, Singapore
Printed and bound by Imago, Thailand

Contents

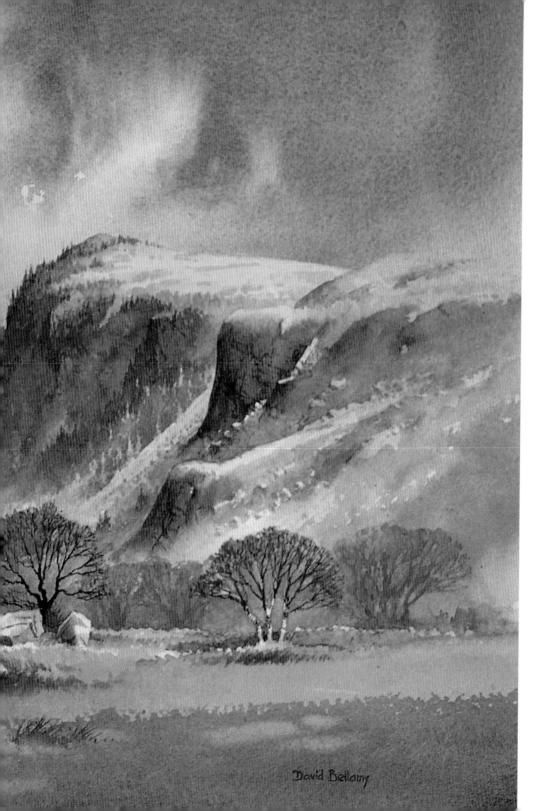

1

Introduction

The wild places have always been part of my life, as vital to me as home or paintbox, uplifting the spirit, providing solace in adversity, inspiration when jaded by winter gloom, or joy when sitting on a snowy summit after the toils of the climb. To sketch in these places, untainted by man's destructive influence, is to me the supreme privilege, the Arcadian idyll that transports me away from the cares of everyday existence, recharging the batteries of hope, and vitalizing the purpose of life.

BLENCATHRA AND WALLA CRAG
28 x 41cm (11 x 16 in)

Blencathra, or Saddleback, exhibits a splendid composition from many angles, although it confounded the Revd. William Gilpin, the eighteenth-century writer on picturesque scenery. He felt that '... *a mountain in Cumberland, which from its peculiar appearance in some situations, takes the name of Saddle-back, (forms) disagreeable lines ... Such forms also as suggest the idea of lumpish heaviness are disgusting...*'.

David Bellamy

Mountains, crags and all manner of wild scenery are popular subject material amongst landscape artists, whether as part of the general backdrop, or as the object of attention themselves. If you enjoy painting them, but are struck by dismay at the thought of actually climbing into these regions of despair, then it hardly matters, for so many are easily viewable from a less terrifying position than balancing on some airy crag while the scene is caught on paper. This book, however, is not just concerned with mountains. Colourful deserts, cool glaciers, craggy coastlines, canyons, caves, gorges, jungles and African savannah are all featured here.

After we cover the basics of painting watercolour landscapes the chapters describe scenery that begins with compositions fairly accessible to the majority of painters, gradually increasing in physical challenge in search of scenes, to more demanding expedition-type work. Not everyone wants to sketch while the very ground you are standing on is lurching about alarmingly, or you are hurtling down a mountainside on a dog-sledge that is virtually out of control, but such moments certainly make for memorable sketching trips. The ground-moving incident occurred on the edge of an Icelandic glacier where it was covered with rock and earth debris that deceived me into thinking I stood on terra firma. As I sketched an ice bridge over a fast-flowing river where it roared off the glacier, I suddenly realized that the 'ground' was actually moving beneath my feet, undercut by the surging torrent, and threatening to deposit me in the glacial maelstrom!

Wilderness means something different to each of us. A pleasant stroll in the foothills for one person might well be an awesome prospect for another. In the mid-eighteenth century when artists began to paint mountains in earnest for their own sake, they appeared as hostile places inhabited by bandits and all manner of evil manifestations, although of course the locals and shepherds knew otherwise.

The development of mountain painting

In Britain the painting of wild landscapes developed during the second half of the eighteenth century. Richard Wilson (1714–82) had already shown that the mountains of Britain could rival the Alps in wild beauty. The painting of landscapes for their own sake, rather than as a setting for other themes was much influenced by Paul Sandby (c.1730–1809) during his work for a military survey of the Scottish Highlands in 1747. He also showed that mountains had a beauty of their own, and were not simply places of dread.

There followed numerous artists such as Francis Towne (1740–1816) whose watercolours, often overlaid with redrawing, embraced not just distant mountains, but more intimate views of waterfalls, crags and precipices; J.R. Cozens (1752–97) who often worked with a cooler range of pigments to emphasize space and scale; and John Varley (1778–1842). The master watercolourists John Sell Cotman (1782–1842) and Thomas Girtin (1775–1802) also engaged with mountain scenery, but generally from a more distant view.

In the wilder atmospheric works of David Cox (1783–1859), who spent much time in the mountains, you really do feel the wind and rain. It was J.M.W. Turner (1775–1851), however, who took the painting of mountain scenery to amazing heights of atmospheric emotion. By his lifetime painting mountains in areas such as the Lake District, Snowdonia and Scotland had become fashionable.

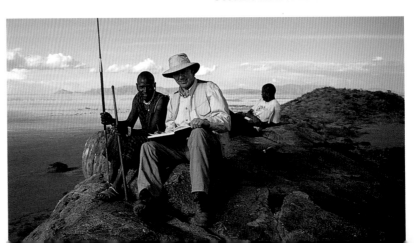

DAVID TEACHING A MAASAI WARRIOR TO SKETCH

Alpine painting

Continental artists were also expressing an interest in wild scenery. From the latter half of the eighteenth century onwards the Swiss artist Caspar Wolf (1735–83) painted many alpine landscapes, often working in high, almost inaccessible places. He was invariably accompanied on his painting expeditions by scientists and botanists.

Another Swiss painter, Alexandre Calame (1810–64), who was eventually regarded as the master painter of the Alps, had to employ many pupils to satisfy the demand for his mountain paintings. He was to influence the Frenchman Gabriel Loppé (1825–1913), who was essentially a self-taught artist and quickly fell under the spell of alpine scenery. We are now entering the realm of the '*peintre-alpiniste*', for Loppé climbed mountains, making no less than forty ascents of Mont Blanc. As well as painting high-level views he was especially enchanted by images of glaciers.

One of Loppé's disciples was Edward Theodore Compton (1849–1921), another climber-artist. Although English by birth, Compton settled in Bavaria while still a young lad. His mountain paintings, in both watercolour and oils, were always accurate portraits combined with dramatic atmosphere, often portraying a high-level panorama. In a great many of his works it is the climbing activity that takes precedence over the landscape, with depictions of alpinists battling up some horrific ice-riven cliff, often in casual defiance of their life-threatening situation.

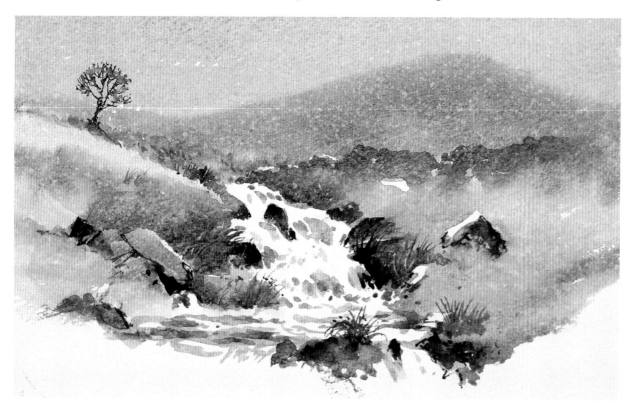

Mountain Stream
Light drizzle, almost imperceptible, fell gently on the washes, adding a lovely accidental texture to the work.

Painting the sublime

Such awe-inspiring situations in sublime scenery characterize a genre of landscape painting that departs in the main from the idea of picturesque beauty and enters one where the viewer takes delight in desolation, awe, wonder, and utter awfulness, although in many cases not excluding the picturesque elements. The sublime evokes sensations of pain, danger and self-preservation, as well as depicting the immensity of these savage places. Turner, of course, was the supreme sublimist, but in North America artists of the calibre of Albrecht Bierstadt (1830–1902) and Thomas Moran (1837–1926) painted grand canvases of the canyons and peaks of Yellowstone, Yosemite and many parts of the western states, bringing the sensational and sublime to a public that at times seemed sceptical that such monumental scenery could exist.

Every artist at some stage will hear the expression 'that painting is so good it is almost like a photograph,' and yet will also be warned that 'when a painting is super-realistic it is no longer art,' so where do we stand? Be yourself – find out what you truly seek from your paintings. If a faithful portrait of a mountain is important to you then your heart is perhaps telling you to take the more realistic route. Otherwise, maybe a looser style is more appropriate. Sometimes it takes us years to determine what we really want.

My own manner of painting falls partway between the realistic and abstract, varying at times according to mood and response to a scene. To impose strident techniques to create a more mannered style goes against the grain in my desire to capture the sheer beauty of much that is in nature.

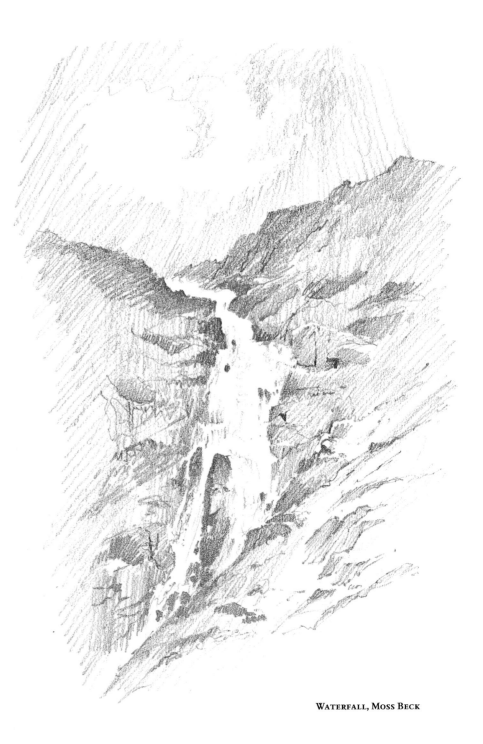

WATERFALL, MOSS BECK

Companions

Having a true companion with whom to share the great outdoors is a priceless blessing, as I have found, even as a child. To have someone who also shares and indulges in the joys of painting as well, is a marvellous bonus, and I am truly lucky in sharing this with Jenny Keal, my wife. She has a strong affinity with the wild places, and though subjected, by circumstance of course, to the most deplorable privations in search of the picturesque, retains a healthy sense of humour most of the time. My other companion on many of the wild trips is my daughter Catherine, who could paint if she wished but has taken a different course in the arts. While I sketch, she usually reads a book, although during one expedition she borrowed all forty two of my watercolour pencils to create textures from some volcanic cliffs, and after twenty minutes had somehow reduced most of them to fire-tinder.

Nature energizes my mood and sets alight the spark of emotion and joy of painting the landscape. Simply touching rough-hewn rock brings a glow inside, and a tremendous feeling of being at one with the landscape. To feel the wind across the summit or hear the song of the stream tumbling down the cwm uplifts the spirit. Whether you are an armchair mountaineer, a rock gymnast with a pencil clutched between your teeth, or fall somewhere in between, if you enjoy painting the more rugged scenery there is something in this book for you.

WIND, ICE AND MIST ON BRISTLY RIDGE, SNOWDONIA
68 x 49 cm (27 x 19 in)

Almost a monochrome, this watercolour painting evokes such terror in Jenny that she will not let me hang it where she can see it.

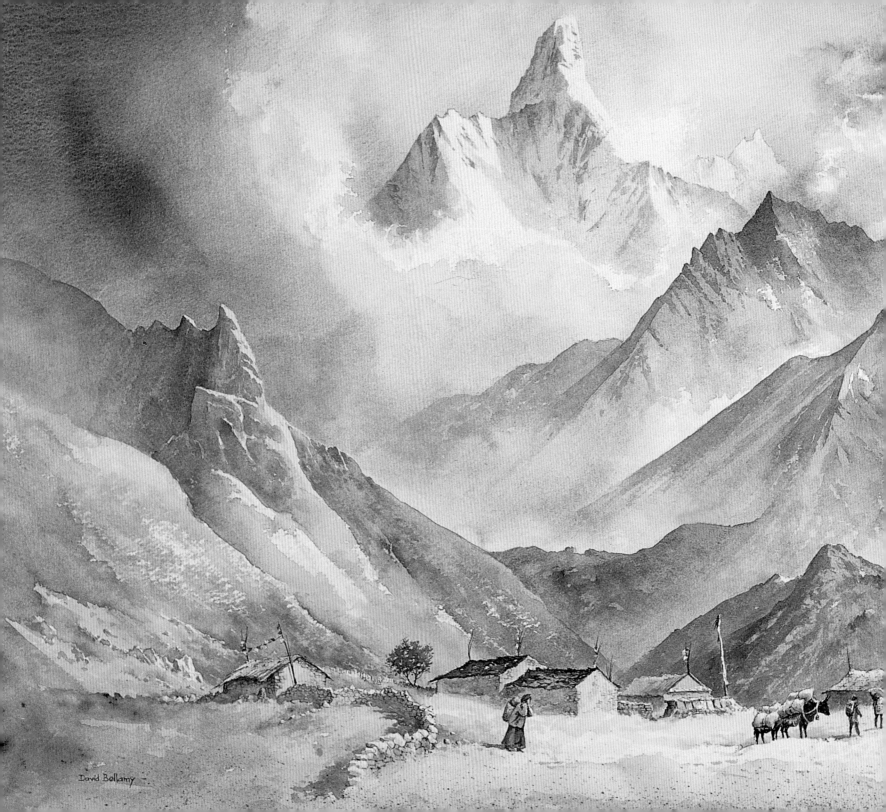

David Bellamy

2
Materials

To work with inferior materials is to work at a tremendous disadvantage. If your tools are not the best it does not follow, however, that you need to go to any great expense to improve matters. Over a period you can gradually build up a selection of the best paints and brushes, with the advantage that you get to know each more intimately than when changing your entire stock wholesale. With regard to paper, a few good-quality sheets may last you a while and enable you to become familiar with its attributes before splashing out or trying a different make. If you are putting art materials on your Christmas or birthday list it is best to be specific about your needs, otherwise you may end up with inferior products.

AMA DABLAM
52 x 70 cm (20 ½ x 28 in)

A painting of the size and complexity of this work needs preparatory studio sketches before drawing the final composition. These sketches would indicate where each main feature is to appear, how it would be treated and any changes that are needed.

Paints

When buying watercolour paints, stick to a reputable manufacturer – be wary of lesser-known makes. All the paintings in this book were produced with Daler-Rowney artists' quality watercolours. Note that if you use a different brand the results of your mixtures might differ slightly from mine, even if you are using pigments with the same name.

I prefer to use tubes in the studio and half-pans out of doors, except on large alfresco works when I revert to tubes. I also carry odd tubes of watercolour outside to supplement the box of pans.

An artist's palette constantly evolves with new influences and ideas, and sometimes when we discover new colours. To list all the colours I use would involve mentioning most of the Daler-Rowney range with a few thrown in from elsewhere, so it will help matters if I restrict it to those I find most useful. I avoid fugitive pigments.

A list of my favourite colours is shown on the right, but as this is such an individual choice you may well have alternative preferences.

Colour splashes
It is worth spending time getting to know your colours intimately, and how they mix. Only by trying your own mixing experiments will you progress, but here are some of my favourites where the amount of each colour is roughly the same. You can vary these quantities and assess each combination.

Cadmium Yellow Pale and French Ultramarine

Gamboge and French Ultramarine

French Ultramarine and Raw Sienna

Cadmium Yellow Pale and Indigo

Gamboge and Indigo

French Ultramarine
A versatile colour that mixes well and creates lovely granulations.

Cobalt Blue
Not such a good mixer as French Ultramarine, but very useful, especially for skies. In tube form it needs to be mixed well, as it has a tendency to leave blobs within the brush hairs.

Phthalocyanine Blue
This comes in red and green shades, both tending more towards greenish than Ultramarine or Cobalt blues.

Indigo
I use this colour occasionally when I need a more sombre mood. It is excellent for mixing greens.

Burnt Umber
Superb for creating intense darks. Mixed with French Ultramarine it produces lovely cool greys.

Burnt Sienna
Mixes well and is a little warmer than Burnt Umber.

Cadmium Red
Another excellent mixer, which I combine with French Ultramarine on many of my skies. I use it in many situations where I need to liven up a passage or parts of a feature for trees or vegetation, or to draw the eye to the focal point.

Light Red
A good colour for mixing with a blue to create warm greys. I often drop it into wet colour to provide interest in walls and vegetation, or when suggesting rust-coloured bracken.

Indian Red
A powerful colour that I often mix with Phthalo Blue to make warm darks when working on tinted papers.

Alizarin Crimson
A lovely cool red that, unfortunately, is a little fugitive in the paler washes. More permanent alternatives are Permanent Rose or Quinacridone Red, although I still prefer Alizarin Crimson for stronger washes.

Raw Umber
A subtle, opaque colour that I use mainly in foregrounds and for creating dull greens.

Raw Sienna
A versatile colour that mixes well and is less opaque than Yellow Ochre, although I use both pigments.

Yellow Ochre
I find this excellent for dropping into wet washes to induce variation.

Cadmium Yellow Pale
This is a lovely, fresh, cool yellow that mixes well to produce or modify greens. I employ it to brighten up an area.

Gamboge
A warmer yellow that will produce more intense greens, and is a superb mixer.

Naples Yellow
An opaque pigment that does not mix well, but it is excellent for skies, stonework and dried grasses.

Viridian
Not a colour I use often, but one of the best greens for mixing, being cool and transparent. Greens are far too civilizing to sit comfortably on the savage palette.

Paper surfaces

A good watercolour paper should not just have an interesting surface texture, but be robust and capable of accepting consistent washes and masking fluid. Most of my work is carried out on Saunders Waterford, a superlative paper of varying weights and surfaces, although I also use Bockingford at times.

The choice of surface type is really dependent on whether your painting will involve fine detail, or if textures are more important, and, of course, that it has a pleasing surface. Be aware that some papers on the market are about as efficacious for watercolours as the back of an old carpet.

Working on a Not surface
A Not surface is a good all-rounder. This watercolour sketch was done on Bockingford 300 gsm (140 lb) paper, which has an interesting surface texture that encourages pleasing washes and allows sharp edges and fine detail to be achieved.

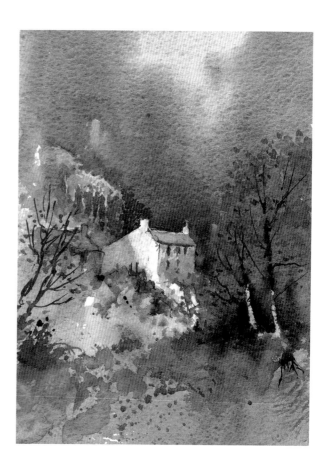

Working on a rough surface
Here the Saunders Waterford rough surface has accentuated the ragged edges of wind-torn clouds by my applying the colour with the side of a round brush.

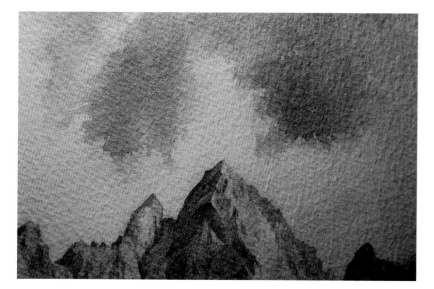

Working on a hot-pressed surface
Where sharp detail is required, as on these plants, a hot-pressed surface works best, but as washes tend to dry more quickly it can be rather a disobliging paper in the hands of the less experienced.

Brushes

A good sable brush with a fine, springy point is still the best tool for applying watercolour, although a sable big enough for large washes would be prohibitively expensive. These days I use squirrel-hair mops for laying large areas of colour: in the early days I used to do this with wide, flat brushes, but these often leave unsightly tramlines across the paper caused by the sharp corners of the brush. It is worth buying only first-class brushes. Most cheap ones will let you down, including cheap sables, which can quickly lose their point. You will need round and mop brushes of varying sizes.

Brush technology is making advances all the time, with new types appearing on the market. Some are a waste of time, gimmicky and of little use, but now and then some extremely useful ones appear. The new flat angled brushes can be effective for certain features like sloping roofs or slopes running down to a lake, for example. It is hard to beat the more traditional tools of round sables, large mops and riggers for fine detail. There are many excellent synthetic brushes on the market as well as those of a sable/synthetic mixture, but make sure they point well before you buy them.

Types of brushstrokes

A rigger, a 12 mm (½ in) flat brush and a fan brush are useful for specific needs and strokes.

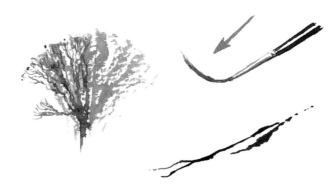

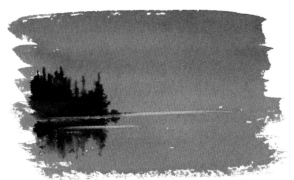

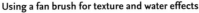

Using a rigger for fine detail
A rigger is effective for intricate detail. On the far left it has been used to paint a winter tree, first using the side of the brush to suggest a mass of branches (as shown by the top diagram), then with a slightly stronger tone to draw in more branches. Before drawing more strongly with the rigger drag the brush across scrap paper, twirling it at the same time to create a fine point.
The lower drawing shows a fracture line produced with a No. 1 rigger, achieved by applying varying pressure on the brush.

Using a flat brush to take out colour
A damp 12 mm (½ in) flat brush will effectively remove slivers of damp watercolour as illustrated in this simple lake scene (see left). It is also useful in this role for removing bits of colour that have strayed below or above the line on a roof, far shore, mountain ridge, or where unwanted on any other edge.

Using a fan brush for texture and water effects
Because of its splayed-out hairs you can easily simulate water cascades, rain squalls, texture on wood or corrugated iron by using a fan brush. For the illustration on the right, combining Cobalt Blue and Cadmium Red, first tested on scrap paper, I laid a few strokes diagonally upwards, easing off at the point where the roof ridge would appear. When it was dry I placed the dark green mixture with a No. 8 round sable over part of the roof to define it, covering some of the extremities of the diagonal strokes. Next the far end of the shed was painted in, going over the lower part of the diagonal wash, but leaving some for you to see the initial application on the left. With a fan you can pick up two or three different colours on various segments of the brush and lay a multi-coloured wash.

Misty sunlight

21.5 x 29 cm
(8 ½ x 11 in)

I used blue-grey
tinted paper for
this watercolour.
A coloured paper
provides an
excellent method of
creating an overall
moodiness and
unity to a picture.

Other equipment

Critical to good painting is having somewhere to work
properly, with good lighting, both natural and a
daylight lamp. Daylight bulbs and strip lighting
provide excellent light for painting, and are available
from most art shops. I prefer to work at a desk, with the
work sloping down towards me, but some artists like to
work at an easel. Whichever manner you adopt you do
need to stand back from the painting every now and
then. It is essential to be able to adjust the angle of the
drawing board to your requirements.

One of the biggest inhibitors for the artist is having
to spend ages setting up, so if you are serious about
painting you really do need to set up your work area for
minimum preparation. Organizing your materials for
maximum efficiency will go a long way to your success.

I find a sponge is indispensable for removing or
reducing a feature, or for softening an edge, so I keep a
variety of sizes at the desk. Apart from correcting
mistakes, it can be used as a creative tool to suggest
mist or spray. Many artists also find masking fluid to
be an essential item.

I use a variety of palettes, some giving a large, flat area
for working, others with generous, deep wells for
mixing large pools of watercolour.

Outdoors I use a range of sketchbooks, both of
cartridge paper and watercolour paper, sometimes
making up my own to contain several types of paper, to
suit the length and type of expedition or trip.

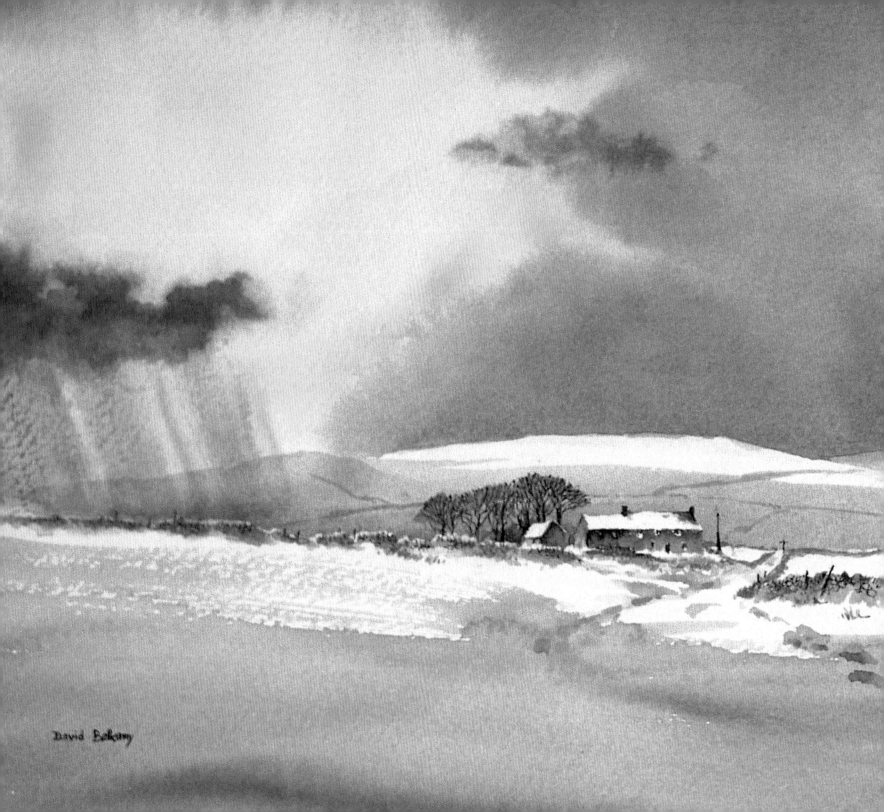

David Bellamy

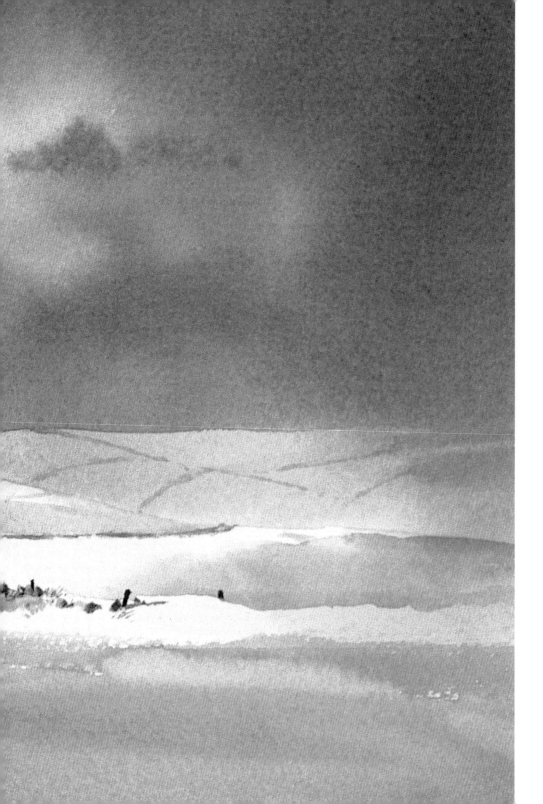

3
Painting Pictures

Every landscape artist has a preferred way of working. Some like to paint outside directly from the scene, often from a vehicle; others are more inclined to work at home in the studio from sketches and photographs carried out on the spot. Yet others copy from whatever source comes to hand, a method that I feel does little to improve their work. On the other hand, there is a warm sense of accomplishment on returning with material that has taken effort to obtain.

Occasionally I paint a full watercolour on the spot, but generally I prefer to sketch outdoors and paint back in the studio. This enables me to change the sky and mood, introduce other elements from other sketches, and gives me more control over the composition. Conversely, working on the spot does yield a spontaneity that is difficult to achieve in the studio.

FARM ON TIDESWELL MOOR, PEAK DISTRICT
22 x 35 cm (9 x 14 in)

The simple foreground:
This scene, because it is uncluttered, would lend itself to a fairly detailed foreground, but I decided to restrain myself. Often, a weak wash, sometimes overlaid with broken colour, can be the best option. Try this 'extreme' approach and resist any temptations to go berserk with a fine brush.

Farm Outbuilding, Iceland

This scribbly original sketch illustrates how a loose approach, starting with light strokes, can set up the image. Once the main features have been established you can then gradually refine the drawing until you can confidently apply bolder strokes. You do not even need to rub out the initial lines. Regard it as a working drawing rather than finished artwork. For a more considered drawing see the 'Barn at Vaujany' sketch on page 41.

My approach in this book, as on my courses, is to illustrate the techniques I use, and to encourage you to experiment with other methods. Often there are numerous ways of achieving the same effect and sometimes it is simply whim that governs which method I employ.

In this chapter we will prepare ourselves for drawing, sketching and painting – each of these disciplines relies on each other and develops as we become more experienced. Initially my own watercolour painting developed more readily as a result of my sketching in watercolour in all conditions than as a concentrated series of studio lessons. I therefore put great store on working directly from nature.

Drawing

Drawing is fundamental to watercolour painting, be it with the humble pencil, pen or brush. Constant practice at every opportunity with each of these, as well as with charcoal, conté crayons and whatever takes your fancy, will accelerate your accomplishment. Work from all manner of household, garden or other subjects in addition to drawing scenery. Study first-class drawings; look at the use of economy of line, the character of each line, and how it varies in strength, thickness and length. Note how tonal effects have been rendered to suggest darker areas, shadows and form without the need to describe outlines, and how textures have been depicted – we can discover much from master draughtsmen. By carrying out detailed studies of various types of scenery you will learn how to describe the landscape and its many features.

Working in watercolour

While most of us have in some way drawn and scribbled for much of our lives, turning to paint tends to tighten our senses, sometimes to the point of panic. The following methods are useful for those who are tentative about applying washes.

When painting a watercolour we normally begin by drawing in the outlines of the various features within the composition, then introducing the colours and tones gradually, working from the lightest to the darkest tones. If you suffer from a lack of confidence in laying watercolour washes an excellent tonic is to take a drawing of a scene that has been rendered with tonal areas – preferably one that has been hatched with lines rather than scribble, which can leave a gloss on the paper that will repel washes. Then lay a series of weak, consistent washes across the drawing, not worrying about overlapping the boundaries of each feature. Let the washes run into one another. The strength of the drawing should hold it together.

That approach is similar to working with pen and wash, where the image and tones have been drawn beforehand with a pen. Try making some photocopies of an ink drawing onto 190 gsm (90 lb) watercolour paper or cartridge paper and have several attempts at laying washes, perhaps varying the approach slightly each time. When you have had some experience of this, start introducing stronger tones, and gradually use the watercolours in a more normal way. Do not be afraid of making a mess – enjoy the experience of pushing paint around. Use plenty of water. This method is not just useful for beginners, but also for those who lack confidence, or wish to experiment. Those who never take risks miss the thrill of the chase, and are denied the exhilaration of that happy accident.

Doodling with a brush

Drawing with a brush is an essential part of watercolour painting, and your work can greatly improve if you practise drawing with a fine brush. Choose a rigger or small round sable for best results. To achieve a really fine point twirl the brush between thumb and first finger while you drag it across the paper. Try doodling with a brush and do not worry if you make mistakes. See what you can achieve with different strokes and pressures on the brush, varying the line in width and direction. Create an image, then add colour washes with a larger brush as in this loose doodle of a cottage. This approach should develop your confidence and help in your more studied and careful drawings.

Applying colour

Graduated wash on a mountain

Sadly, the graduated wash is not used as often as it might, even though it may enhance a watercolour. Study some of the paintings here and you will see how this method can be much more effective than simply flat washes. Here it creates interest and variation on a cliff face.

Variegated colours on a barn

Many subjects, such as rough walls, roofs and mountainsides, benefit from applying a base wash; then, while still wet, dropping in other colours to blend into the wash. This not only adds interest, but is a useful substitute for detail.

Scrub-wash to create clouds

The scrub-wash is one of the less romantic methods of applying colour, but looks extremely effective. Where you need ragged edges, such as on clouds, texture or vegetation, applying a wash by dragging the side of the brush across the paper gives a more broken edge and tends to leave occasional gaps, depending on the roughness of the surface. The clouds below were rendered in this way, in places running the scrub-wash into a wet area to blend it into the background, but mainly on dry paper to suggest clouds boiling up in a mass.

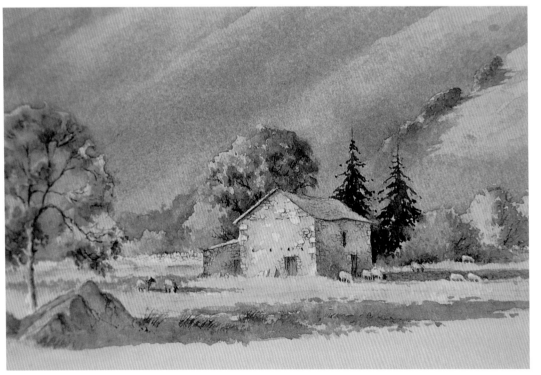

Creating highlights

Take the process a step further by dropping other colours into the wet washes you have just applied, varying the time you allow the initial washes to start drying. These interesting effects will show you how far you can go to create varied washes. The next stage is to consider tonal variations, beginning with white. As the lightest possible tone in watercolour is the white paper you are working on, it is vital to leave untouched those passages that need to be left white, to create the highlights. Do further washes leaving different parts of the drawing free from paint and see how in the resulting work the eye is drawn immediately towards those highlights. Without highlights a painting has the charm of stale porridge.

Next lay increasingly darker applications of paint and gradually build up the picture a step at a time. All the time you should be planning a few steps ahead. This is particularly important with regard to the passages that are adjacent to the one that you are currently painting. The choice of colour, tone, fluidity and other variables will greatly affect not just the part you are working on,

but all those areas around it. For instance, a colour with a warm temperature will make an adjacent passage appear cool, and vice versa; and the darker the tone, the lighter will the abutting area look. Of course, there is also the choice of blending in the two areas, or creating a sharp-edged contrast. A busy section often calls for a more simple, uncluttered neighbouring one. Allied to this problem is that of overlaying objects such as tree trunks or fences over a background field, figures against all manner of features, laying broken colour over an already dried wash, or creating light-coloured boulders against a dark background, for example. In each of these cases the approach needs to be worked out before you apply the first wash.

Layering colours
The effect of overlaying bands or washes of darker colours over lighter ones is at its most arresting when the colours used are in harmony with each other.

Adding colour to small features
The simple expedient of dropping yellow, green or red into a wet grey fence post improves it immeasurably. This can be done on many similar features.

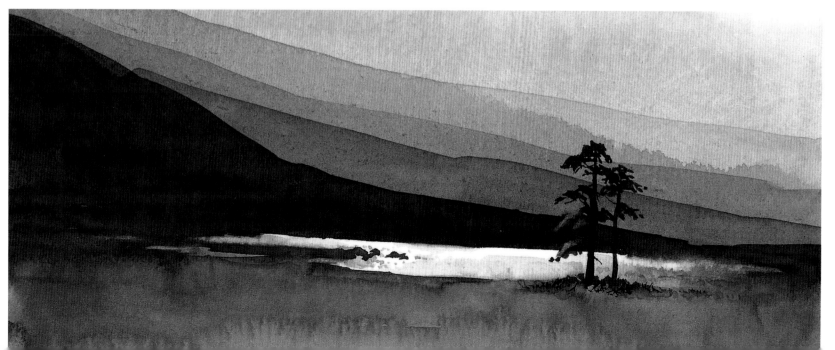

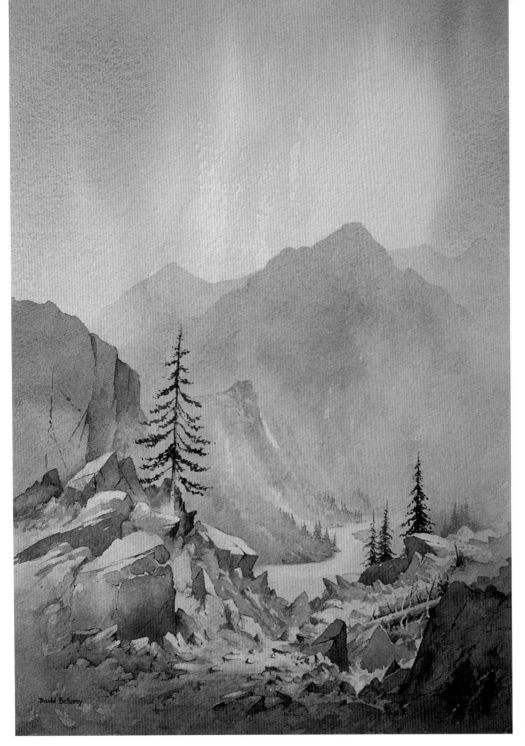

Strengthening the composition

Many problems, such as overcrowding an area, are affected by the composition, so if you are producing a picture that is more complicated than copying a simple sketch or photograph it makes sense to do one or two thumbnail sketches to work out where all the various features are to appear. Composition, like most elements involved in painting, is something we can improve on with experience.

The foreground is a particularly difficult part of the painting, and should be considered carefully when drawing out the initial composition. Your treatment here depends to some extent on the rest of the composition, taking into account the amount of detail in the middle distance, where the focal point is to be placed, and whether the subject needs strength in the foreground for some reason. Strongly detailed rocks, plants, posts and such in the foreground can help throw a sense of depth across a painting, but beware of giving an impression of barbed-wire entanglements and obstacles that seem to be the hallmark of many foregrounds. You do not wish to inhibit the eye of the observer from arriving at the centre of interest. It is always good to provide a lead-in, but the viewer should not need a tank to reach the focal point.

OVERLOOKING THE RIVER DERWENT
32.5 x 24 cm (13 x 9½ in)

By working with a monochrome or limited colour range many of the technical problems with watercolour painting are eliminated. You can forget colour mixing and concentrate on applying washes and getting the tones right. While this is especially helpful to the inexperienced, it is also a powerful way of creating unity and mood.

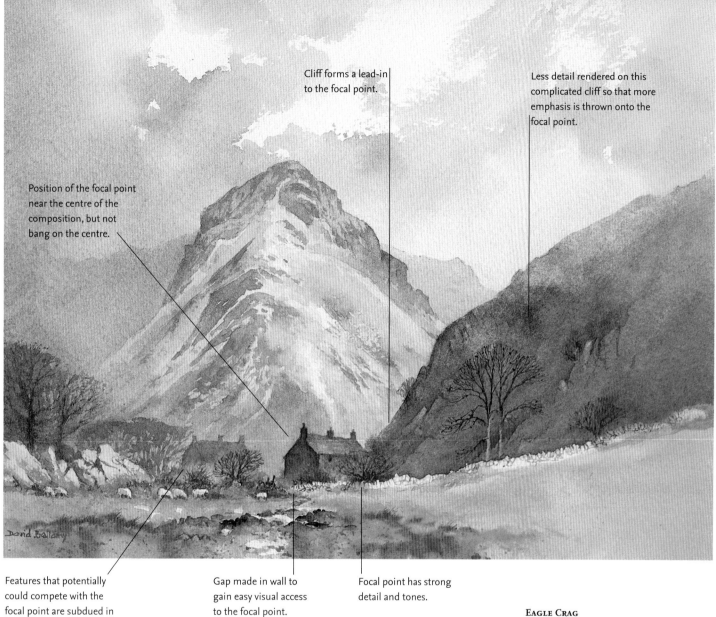

Cliff forms a lead-in to the focal point.

Less detail rendered on this complicated cliff so that more emphasis is thrown onto the focal point.

Position of the focal point near the centre of the composition, but not bang on the centre.

Features that potentially could compete with the focal point are subdued in detail and tone.

Gap made in wall to gain easy visual access to the focal point.

Focal point has strong detail and tones.

EAGLE CRAG
20.5 x 25.5 cm (8 x 10 in)

In this Lakeland scene, where several buildings are visible, the composition was improved by subduing the left-hand cottage, which would otherwise compete with the main building as a focal point. Tonal contrast is exaggerated for the centre of interest to strengthen it, making the larger building the most detailed part of the painting with bright colours splashed on and around it.

Retaining whites

As the white paper is the lightest tone you can achieve in a watercolour, you need to consider carefully as to where these highlights will appear, before you start painting. You can remove wet paint by dabbing with a tissue, or lifting out with a damp brush or a sponge, or scratching out small areas with a scalpel on a dried wash, but these methods are often unconvincing. Here we look at two other means of retaining these precious white spaces.

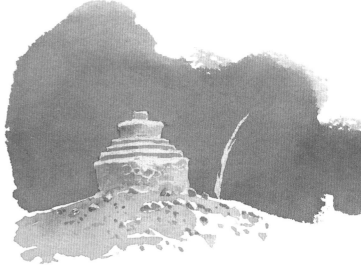

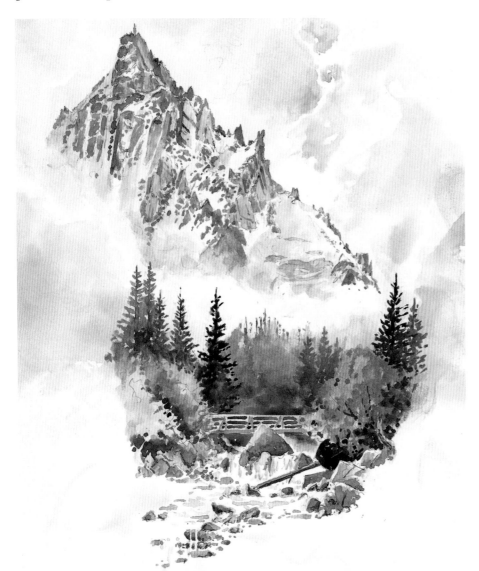

Using masking fluid

Rubbery masking fluid is a popular way of reserving white areas, whether a single line, spot, or larger passage. It is especially good for sharp-edged features such as buildings or boats, but with care can be used on all manner of objects. Before doing any painting apply the fluid to a dry surface with an old brush – you do not want to have your best sables clogged up. After using the fluid clean the brush in warm, soapy water. I find the small sachets of shampoo found in hotels are particularly useful for this job.

Having allowed the fluid to dry it can then be painted over until you are ready to remove it with your finger or an eraser. It is best not to leave it in place too long; less than 24 hours preferably. In this example the masking fluid was applied to a Himalayan chorten and prayer-flag posts. I then painted over part of the feature.

Negative painting

See how the footbridge was rendered by simply painting the dark spaces in between the railings in this watercolour sketch made at Aiguille du Midi, France. With practice this can be the supreme method of creating detailed highlights.

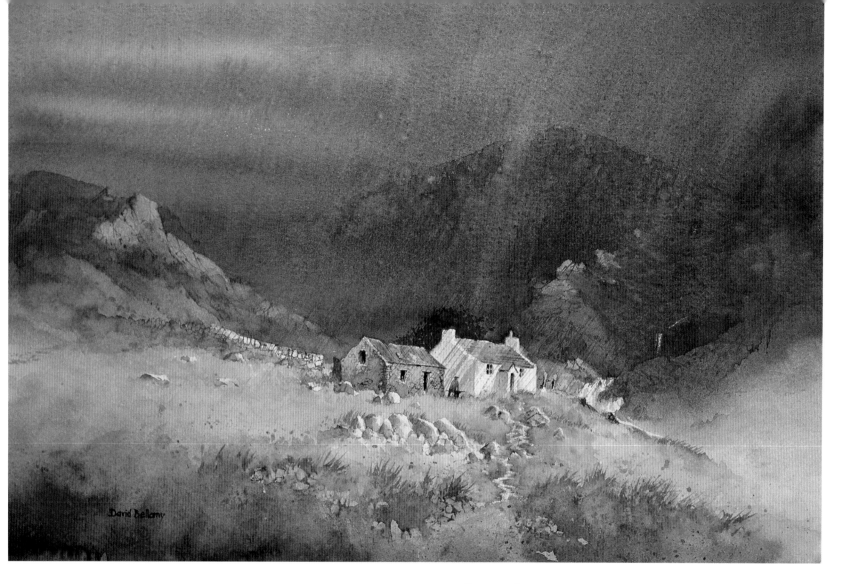

HIGHLAND COTTAGE

22 x 31 cm (9 x 12 in)

Many artists are reticent about painting large areas of dark tones in a watercolour, but in this low-key work dark passages of gloom transfer a sense of light on the cottage and its immediate surroundings. A common error by the inexperienced in attempting these more powerful tones is to half-heartedly apply a series of washes, gradually making them darker as it becomes apparent that the previous wash did not achieve the required degree of darkness. This repetitive laying on of washes will simply create mud. We need to get it right first time by being bold and going for a really dark mixture. As with anything experimental, try the wash first on a sheet of scrap paper.

Creating a sense of space

To emphasize a feeling of space and distance do not make your focal point too large, soften the more distant features and preferably use cool blues and greys for these areas. Strong contrast, with harder edges on the focal point and softer ones to outline elements beyond, really suggests a sense of spaciousness.

BEINN DAMPH

15 x 23 cm (6 x 9 in)

In this small watercolour the actual mountain is unimportant to the picture; it is all about emphasizing a sense of space in open country. The background mountain ridge was painted into a wet surface to create a soft, misty effect. White paper was left to suggest snow gullies and patches, with colour taken out in places with a damp brush. The tree is the key to this effect, for not only is it the centre of interest, but its sharp rendering is in such contrast to the background that it implies a feeling of distance and space.

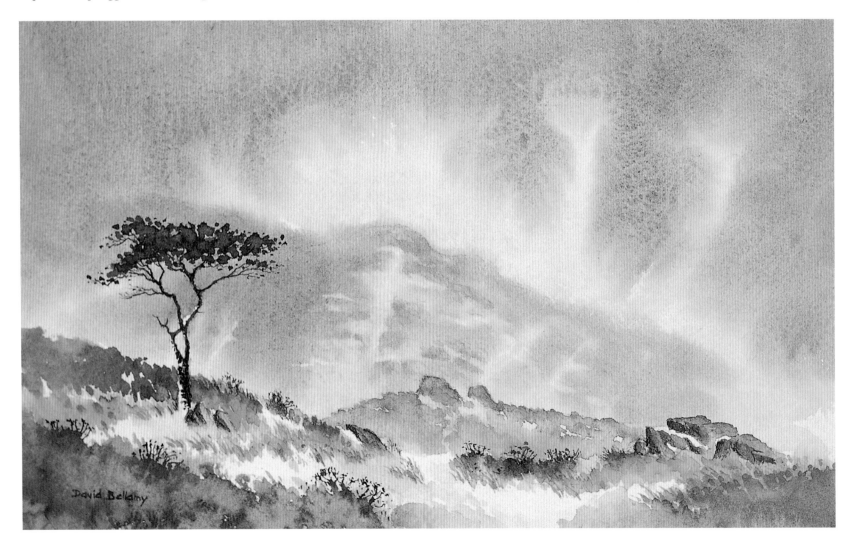

BRECON BEACONS IN SNOW

15 x 24 cm (6 x 9 in)

Dark, hard-edged trees push the mountains into the distance, but here the chief lesson is to illustrate how to suggest one object passing behind another. The left-hand peak of Cribin is faded out as it goes behind the tall left-hand cluster of pines, creating an illusion of distance and space between trees and mountain. This method can also be used convincingly on objects that are close together, having the additional advantage of making the closer object – often the focal point – stand out more clearly.

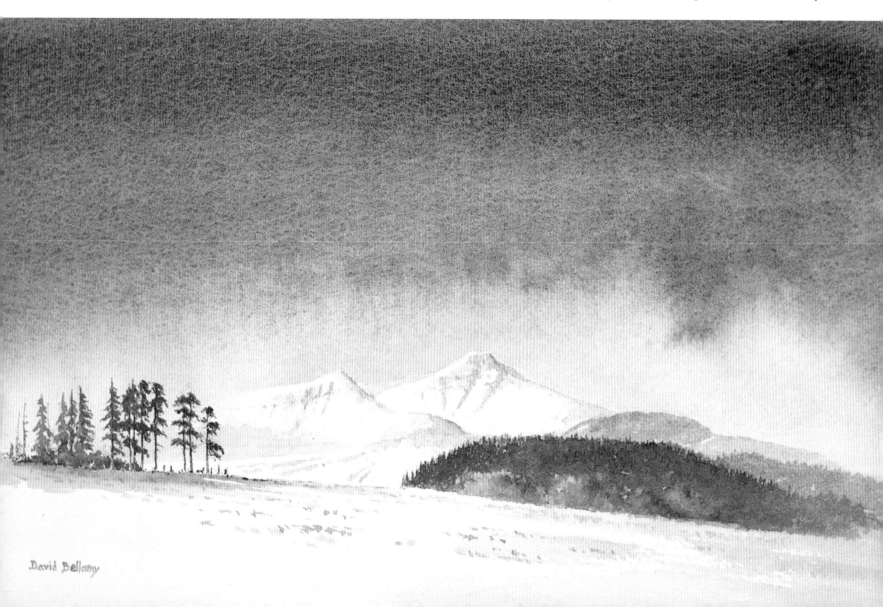

David Bellamy

DEMONSTRATION:
Cottage on Skye
21 x 29 cm (8 x 11 in)

In this fairly simple composition of a cottage surrounded by wild mountain scenery I used a basic approach to building up the picture, with a few devices here and there to add interest.

Stage 1

It is essential when working to keep the board at an angle of about 20 degrees, sloping towards you, to allow the washes to run downwards. I chose a Not surface because of the detail in the building and the dry-stone wall, although a rough surface would have enhanced textures and clouds. Sometimes there is a case for using either, so you need to assess your priority in choosing the optimum paper. Usually it is best to begin with the sky, as it sets the mood, and is normally the lightest passage. A wash of French Ultramarine defined some of the white clouds, and a weak wash of Naples Yellow warmed up the right-hand sky, blending softly into the wet blue paint and drifting down faintly over where the mountain would appear. It was left to dry.

Stage 2

The background mountains were painted with a mixture of French Ultramarine and Raw Sienna, with the lower parts simply in Raw Sienna. While this was still wet I applied Cadmium Yellow Pale to the foreground field to highlight the area where the centre of interest – the cottage – would stand. I deliberately kept the white paper clear of paint where the cottage would appear – you could use masking fluid for this purpose if you wished. When the paper was dry I laid clean water across the sky, bringing it down to where the trees would be, then dropped a medium tone of French Ultramarine mixed with Burnt Umber into the top left-hand corner of the sky. This was allowed to drift downwards over the mountain ridge to create a rain squall, helped by the wet paper, which also ensured that the edges of the squall would remain soft.

Stage 3

I defined the main ridge with a mix of Raw Umber and French Ultramarine, leaving gaps to suggest rocks and crags catching the light, and dropping Light Red and Raw Sienna into the lower part of the wash while still wet. The technique of applying broken colour or gaps in an overlaid wash illustrates the importance of planning the treatment of adjacent passages while working on the current one. I laid Light Red on the roof and immediately dropped a Burnt Umber and French Ultramarine mix into the bottom part to seep upwards. This not only added interest but is also a valuable method to use where the roof needs to be darker against the white walls, yet lighter higher up.

Stage 4 Finished painting

The front wall was painted with French Ultramarine and Cadmium Red, with a stronger version to suggest a distant mass of trees on the left, working round the fence posts. The closer ridge was achieved with French Ultramarine, Raw Sienna and some Cadmium Yellow Pale. For the reeds I used Cadmium Orange. I chose a mixture of Raw Umber and French Ultramarine in various tonal strengths for the dark conifers that defined the left-hand chimney and birch foliage. The detail on the wall was drawn with French Ultramarine and Burnt Umber using a No. 1 rigger. In order to throw more emphasis on the cottage I laid a wash of French Ultramarine and Cadmium Red across the right-hand foreground, running it into pre-wetted paper. Finally the fence wire was scratched out with a scalpel.

Foreground treatment

The foreground has always been one of the most troublesome parts of a painting. By including strong detail and tones in this area a painting is given a sense of depth, but this also can make it appear overworked. On the other hand, too simple a foreground can result in an unfinished look. Much depends, of course, on the treatment of the other parts of the composition, and how they relate to the foreground. We look at four types of foreground – three are shown here, while the first, a very simple foreground, can be seen in 'Farm on Tideswell Moor, Peak District' on pages 18–19.

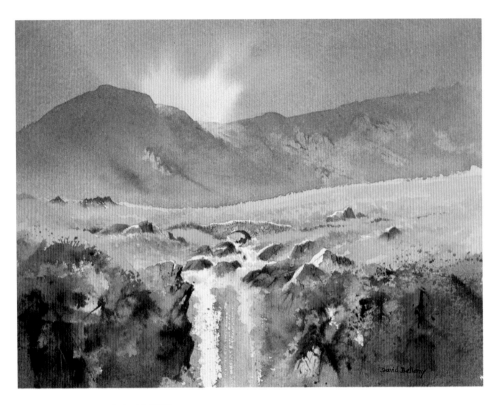

Pisco Chico, Peruvian Andes
23 x 32 cm (9 x 13 in)

The detailed foreground:
Here the strong foreground detail is set against a quiet part of the painting, and helps to create a sense of distance between the viewer and the peaks. This type of foreground works well where there are large areas of the composition devoid of detail, such as the sky and other passages. In a landscape, plants, flowers, trees, vegetation, rocks and water make excellent foreground objects, as well as figures, animals and man-made features. Note the softened edges to enhance a feeling of depth.

COVE BECK, LAKE DISTRICT
20.5 x 25.5 cm (8 x 10 in)

The abstract foreground:
Blending the foreground into an abstract
based on natural forms can be especially
beneficial where complicated foreground
arrangements threaten to overwhelm the
composition. By loosely basing the abstract
shapes on the actual objects, and perhaps
exaggerating colours and tones, the abstract
part can be in keeping with the scene. Try
spatter, water spray, scratching and
scumbling, as well as the more usual
methods of applying paint. Practise abstracts
initially on scrap paper and old paintings
that have not worked.

PACKHORSE BRIDGE NEAR LOCH CLUANIE
30 x 21 cm (12 x 8 in)

The vignetted foreground:
Vignetting is an excellent way to lose
excessive or repetitive foreground detail, and
this can vary from wholesale elimination of
features to just losing a little detail here and
there. Where there is a mass of pebbles,
grasses, plants, ripples or, as in this case,
rock outlines, these can be considerably
reduced by delineating just a few examples,
or losing others by fading out detail as in a
Victorian photograph. Complicated
foreground rock structures here have been
simplified by suggesting a few critical
examples, allowing the viewer's eye to fill in
the rest subconsciously.

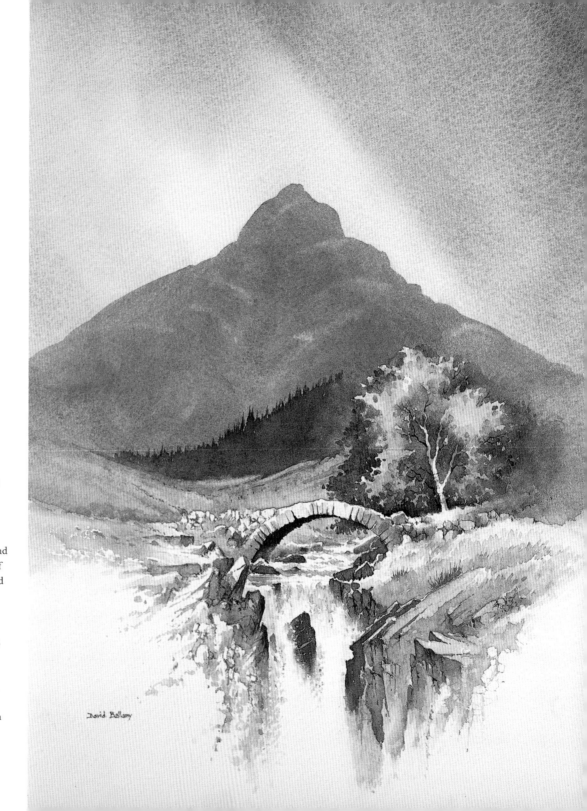

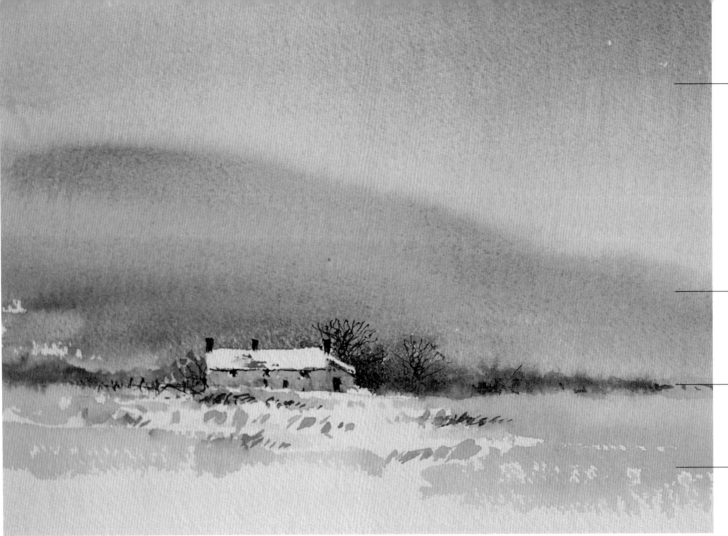

Main sky wash of French Ultramarine with a tinge of Cadmium Red.

Hill applied wet-in-wet with French Ultramarine and Light Red, avoiding the building.

Dark bushes painted with French Ultramarine and Light Red.

Raw Sienna in the foreground, leaving white paper in much of the centre to add vibrancy. Some Light Red splashes added in places.

Impressionistic simplicity

Moorland Farm

18 x 28 cm (7 x 11 in)

In this watercolour I wanted to create a simple impression rather than render strong detail. Only French Ultramarine, Light Red and Raw Sienna were used. First I brought a French Ultramarine wash down into a wet wash of Raw Sienna in the lower sky, then immediately applied a pre-mixed wash of French Ultramarine and Light Red, working around the snow-covered roof. I then applied more Raw Sienna to the foreground area, blending it into the bottom of the previous wash. All the washes were completed within five minutes, using a squirrel mop brush. The painting was left to dry. After the wall was painted and dabs of Light Red and Raw Sienna splashed in places, the final act was to draw details in stronger tones with Light Red and French Ultramarine using a small round sable brush. This type of impressionistic painting has tremendous appeal and is an excellent way of gaining confidence if you are a less experienced watercolour painter.

Painting a farm

The photograph shows Brotherilkeld Farm in Upper Eskdale on a lovely sunny evening as long shadows are cast across the grass. Have a go at painting this – you may wish to add sheep, a farmer, a tractor, or whatever, or just paint it as it stands.

Usually in a scene something needs to be changed, added, lost or improved, but it is hard to think of any improvements to this delightful setting. Once you have finished, and not before, check out my version on page 118, but do not worry if yours differs vastly from mine – that is the charm of painting!

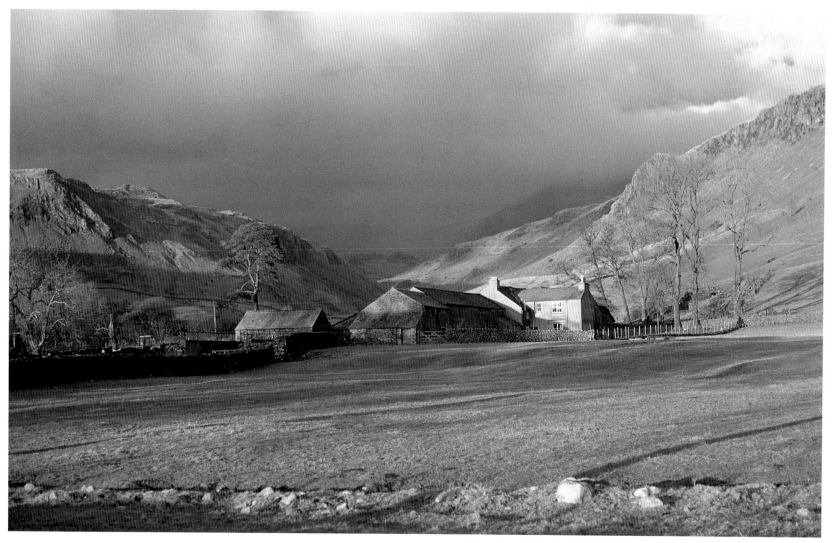

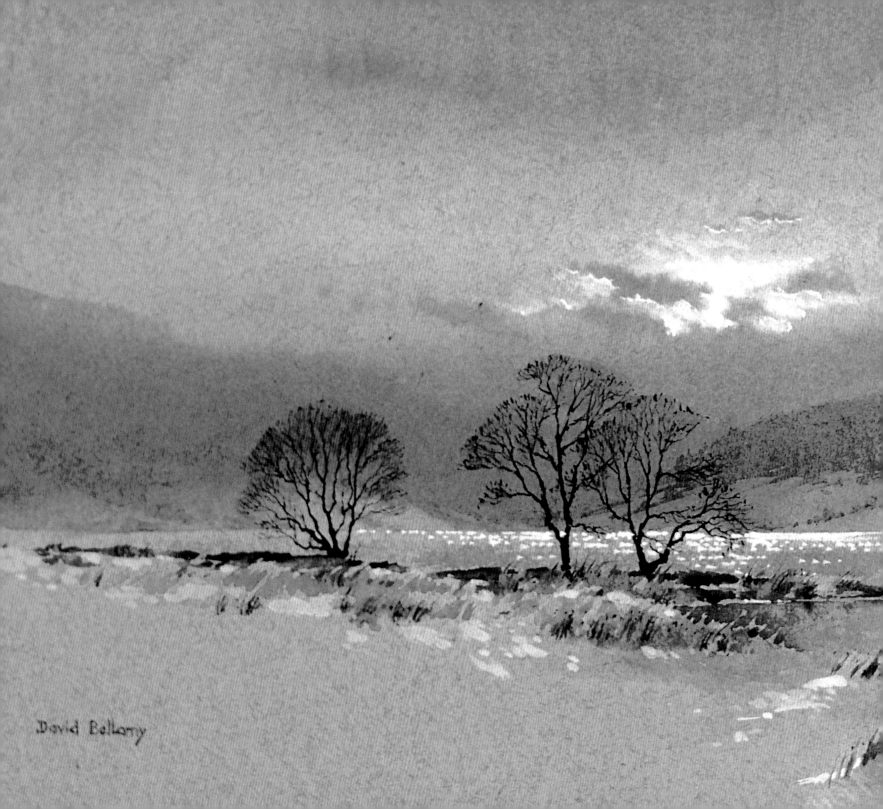

David Bellamy

4
Into the Great Outdoors

We shall now take a look at sketching and painting out of doors in a variety of locations and conditions. Many people become concerned about working in the great outdoors, even in groups on painting courses, when in fact it can be one of the most relaxing and therapeutic activities. Obviously, if you take along an easel it will attract bystanders, so if you wish to remain unmolested it helps to carry the minimum of equipment and try to look as though you are writing notes. You can achieve much with pencil or charcoal. Most of my sketches are made with a 3B or 4B pencil, often in a position where it is difficult for people to see what I am doing.

LLYN CWELLYN, SNOWDONIA
22 x 32 cm (9 x 13 in)

This is a watercolour and gouache painting carried out on rough Australian Blue Lake paper. Tinted papers such as this impart a strong sense of atmosphere in a landscape painting, and encourage the artist to leave large areas of the paper untouched, as in much of the foreground. The highlights were brought out with white gouache. The scene was considerably simplified.

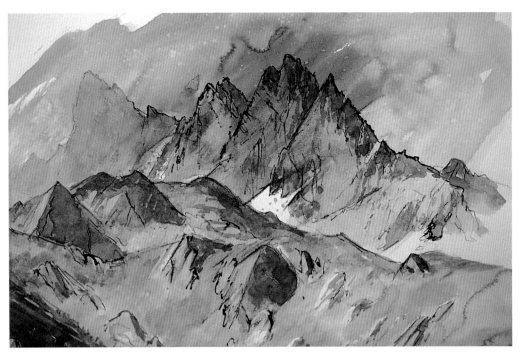

**DAVID SKETCHING ON THE
SERENGETI PLAINS**
Here I was completely surrounded by
hundreds of wildebeests, most of them
making absurd snorts and grunts at my
presence. After a while they lost interest in
my sketching antics and moved off.

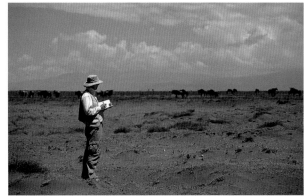

WINTRY SQUALL
This sketch was made in less-than-ideal
conditions during a wintry squall in the
French Alps. Because I wanted to capture the
atmosphere I used watercolours on cartridge
paper, reinforcing the image with a black
watercolour pencil drawn into the wet
washes. Note the sleet-spots on the surface,
especially in the sky.

Watersoluble graphite pencils are superb for
landscape sketching, enabling you to introduce a
lovely sense of atmosphere, more so than one
normally expects from an ordinary pencil. This is
achieved by laying the image and tones on to dry
paper – I normally use a cartridge pad – and then
washing it over with a wet brush. Scribbling with the
pencil can be effective to create masses of tone, then
'licked' into shape with a damp brush.

Aquash brush and watersoluble pencils
The hollow handle of the plastic brush unscrews and can be filled
with water. When you use the brush, the harder you squeeze, the
greater the flow of water to the tip. In combination with watersoluble
graphite pencils this is a superb combination when you do not wish
to carry a lot of sketching gear, or when working from a boat, train or
the back of a camel, without the need for a water pot.

Sketching in colour

Some scenes demand colour sketches, so I find a small box of half-pans vital for this. Watercolour sketching frees you from many of the constraints attached to painting at home. It helps you to quickly learn brush handling and laying washes, and because the sketches will not be for exhibition you will not feel so concerned about getting them right. This not only makes potential mistakes less cataclysmic, but helps you develop confidence in your painting. If anyone sees the sketch you always have the excuse that it was snowing, too hot, too cold, too wet, too dry, too windy, not windy enough, or a wild dog was pestering you.

I regularly lay watercolour washes on without preliminary pencil work, then draw into the wet washes in a linear way with a dark watercolour pencil to create the image. The advantage of this method is that it is extremely fast – you do not need to wait for washes to dry – and you can continue working in rain, snowfall or when inundated by some underground waterfall from which it is difficult to escape. Should the colour be washed away by deluge the watercolour pencil outline will remain, even if you have to close the sketchbook and put it away soaking wet into your bag. I rarely use watercolour pencils for laying on colour areas, except in conditions well below zero when applying watercolour washes is like trying to spread hard butter with a darning needle.

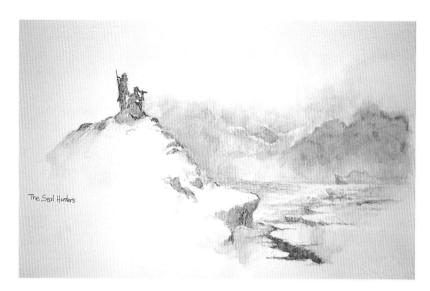

THE SEAL HUNTERS

This sketch was made on cartridge paper. First the image was drawn with a watersoluble graphite pencil, then it was washed over with clear water to create tones of varying strength. The hunters are looking across sea ice at Ikkateq, Greenland, keeping a weather eye open for polar bears.

PEAKS IN THE LATEMAR RANGE, ITALY

Here a simple colour sketch was made entirely with watercolour pencils brushed over with water after applying the various colours. By blending the colours into one another before applying the water, lovely effects can be achieved. In places I have drawn into the wet surface especially to define linear images. The colours on a small sketch like this can also be applied or wetted with an Aquash brush, though it is a little small for larger pictures.

Responding to a view

The tendency with many artists is to make the focal point quite large relative to the overall size of the composition. Here we look at three different responses to depicting buildings in the mountains. In each case feelings, mood and a sense of place are as important to the painting as character, aesthetic and picturesque considerations.

GLAN LLUGWY FARM
In this colour sketch the farm is tiny compared with its vast surroundings, lending a sense of isolation and loneliness, as well as making the mountains appear so much larger than would be the case with a bigger building. This approach allows more information to be displayed for the setting.

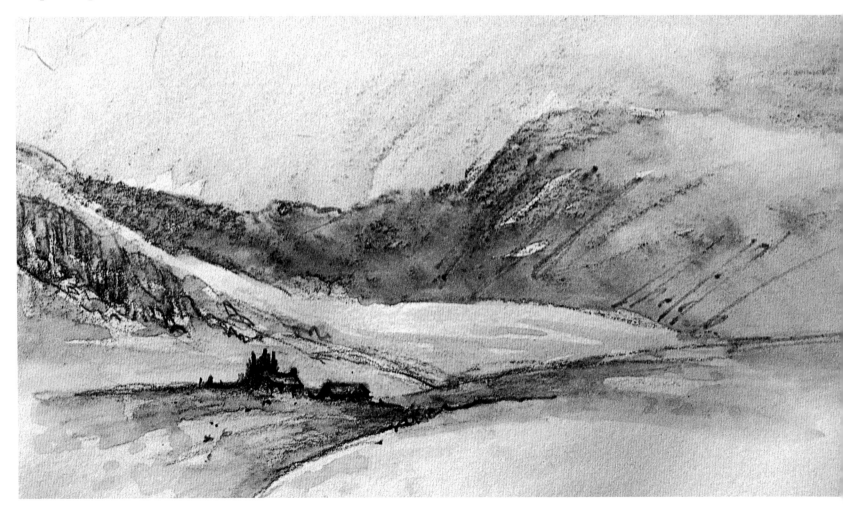

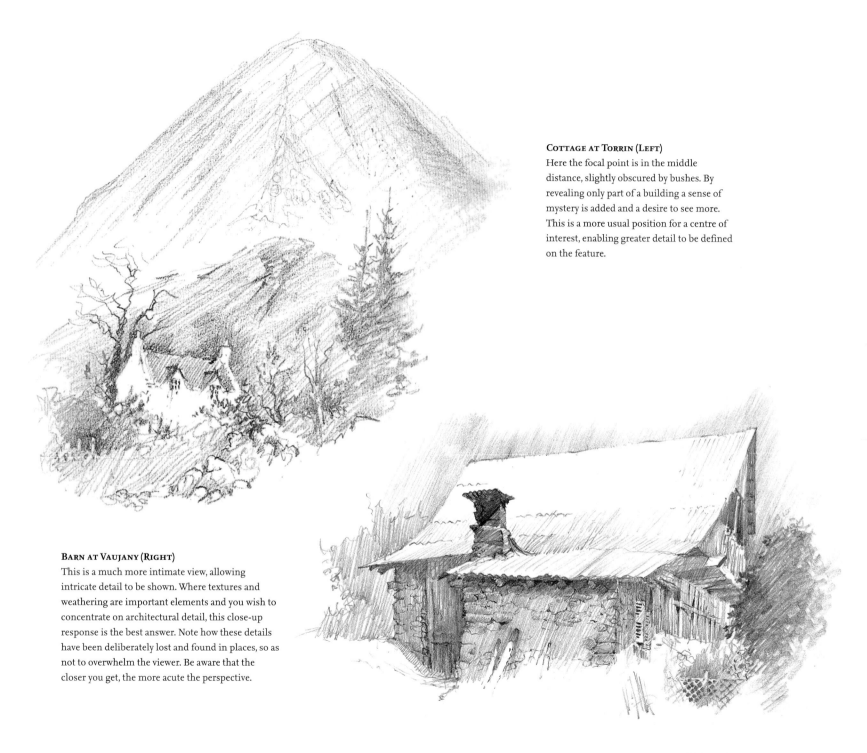

COTTAGE AT TORRIN (LEFT)
Here the focal point is in the middle
distance, slightly obscured by bushes. By
revealing only part of a building a sense of
mystery is added and a desire to see more.
This is a more usual position for a centre of
interest, enabling greater detail to be defined
on the feature.

BARN AT VAUJANY (RIGHT)
This is a much more intimate view, allowing
intricate detail to be shown. Where textures and
weathering are important elements and you wish to
concentrate on architectural detail, this close-up
response is the best answer. Note how these details
have been deliberately lost and found in places, so as
not to overwhelm the viewer. Be aware that the
closer you get, the more acute the perspective.

Alfresco painting

It is rare that I do finished paintings out of doors, except on some expeditions when there is more time. If you prefer to paint outside regularly you will need some sort of protective covering to shield the watercolour from the elements, whether an umbrella, or purpose-made canopy. In difficult conditions take advantage of every scrap of natural shelter you can find. Use time waiting for washes to dry to work on sketches, colour notes and observations; this is especially helpful if you have to finish prematurely, as these sketches and notes will enable you to complete the painting at home.

Finding subjects

In the countryside we are blessed with a wide range of subjects, yet as each of us views the landscape in a different way, we all have definite preferences. Tastes also need to be developed, and so it pays to be open-minded about scenery and to tackle views and subjects that might not immediately appeal: how often while filling in time waiting for Jenny to complete her sketch, I have half-heartedly begun another, only to find it is the best work I have done for ages. Similar discoveries happen to her. Nevertheless, it does pay to concentrate on those subjects that really appeal to you.

Skeidararjokull
17 x 33 cm (7 x 13 in)

In this alfresco of the Skaftafell peaks the edges of mountains rising into cloud were softened with a damp brush. This absolutely wild terrain had the glacier to the east, a glacial lake with icebergs to the north and a savage gorge with raging torrent to the west and south. Catherine and I were completely cut off from civilization and we revelled in it.

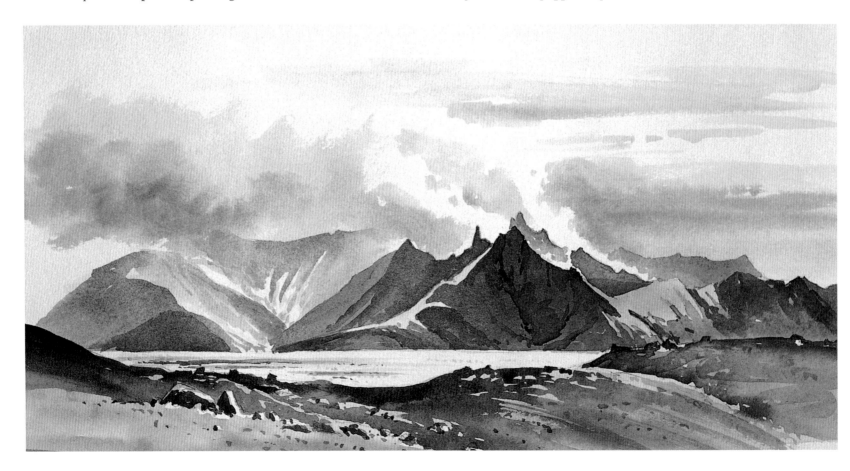

You may be especially attracted to mountains, crags, lakes, streams, old stone bridges, trees, cottages in the landscape, or other features. I take great care to plan my trips into the landscape to seek out the subjects I enjoy. Large-scale maps of 1:25,000 scale not only help me locate known subjects, but provide a good idea of the terrain characteristics. They also give me some indication of whether the mountains are rocky, craggy or smooth, rounded peaks, as well as the steepness, the contours and so much more. Close examination will often reveal the likelihood of a possible composition. I plot a walk to take me past as many potential subject sites as possible. Where the map indicates a craggy face with a stream leading up to it this has possibilities, especially if waterfalls are marked. By walking upstream the visual aspect is usually better, as you can rarely observe cascades properly from above.

Carrying out the sketch

What is it about the scene that has excited you? Spend a few moments simply looking at the subject. By moving are you likely to get a better viewpoint? Should you move in closer, or step back perhaps? Critically, what will be the centre of interest? These are points that should be going through your mind as you work out your approach. Without a centre of interest the composition lacks attraction, so if nothing stands out why are you contemplating it? Often a general view of a picturesque scene can have great appeal without any outstanding feature, in which case you would need to emphasize some aspect of the scene with stronger detail or contrast, brighter colours, or perhaps by bathing the feature in sunshine.

I usually begin the sketch with this focal point, working outwards and noting any possible lead-in, such as a path, lane or stream. Support the focal point with other features, rather than have it stand isolated. Filter out any unnecessary information but make sure

High Lodore Farm
27 x 20 cm (11 x 8 in)

In this pen and wash sketch on cartridge paper I have slightly overdone the crags by being too heavy-handed with the pen for a background area. Penwork lends itself to architectural subjects, and where you have applied much hatching and cross-hatching to create dark tones you need only lay weak washes over the drawing. Here I have applied stronger tones with colour in places.

Pen and ink is also an effective method of salvaging a watercolour that has not quite worked because the tones are not strong enough to define objects within the composition. Pen drawing is best carried out on smooth cartridge paper or a hot-pressed surface, as nibs can scratch badly on a more textured paper.

you have enough to complete the painting back home. If in doubt, put it in, as the sketch is a working document, rather than the finished piece.

Working in bad conditions

When you are out seeking subjects to sketch and paint it is expedient to be able to work in less-than-perfect, even atrocious, weather if the scene really grips you. So long as you are well kitted out this should not be a major problem. A high percentage of my best sketches have been done in foul conditions, partly due to the atmosphere, but also because they are often made with gay abandon in an effort to get something down quickly. Watersoluble graphite pencils and watercolour pencils are absolutely indispensable in wet conditions.

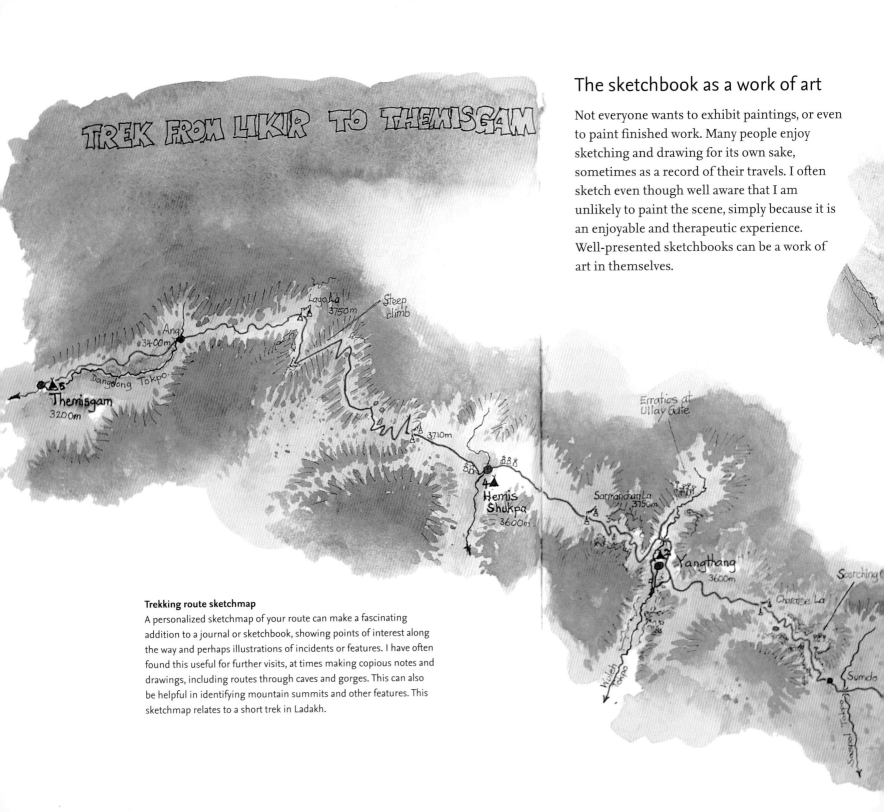

TREK FROM LIKIR TO THEMISGAM

Themisgam 3200m

Ang 3400m

Dangdong Tokpo

Lago La 3750m

Steep climb

3710m

Hemis Shukpa 3600m

Erratics at Ullay Gate

Sarmanchan La 3750m

Yangthang 3600m

Scorching

Charatse La

Walleh Tokpo

Sumdo

Saspol Tokpo

The sketchbook as a work of art

Not everyone wants to exhibit paintings, or even to paint finished work. Many people enjoy sketching and drawing for its own sake, sometimes as a record of their travels. I often sketch even though well aware that I am unlikely to paint the scene, simply because it is an enjoyable and therapeutic experience. Well-presented sketchbooks can be a work of art in themselves.

Trekking route sketchmap
A personalized sketchmap of your route can make a fascinating addition to a journal or sketchbook, showing points of interest along the way and perhaps illustrations of incidents or features. I have often found this useful for further visits, at times making copious notes and drawings, including routes through caves and gorges. This can also be helpful in identifying mountain summits and other features. This sketchmap relates to a short trek in Ladakh.

After further sketching we continued and soon came
to another establishment run by a Woman's Alliance.
An ancient lady with a face wrinkled like a boiled
onion posed for me — when I showed her the
result she seemed most indignant, whilst all
her friends fell about with laughter...

Illustrated journal
The sepia notes are an extract from my
Ladakh journal, while the drawing is from
one of my sketchbooks. I often use pen
drawings to break up my journal text, and
sometimes cartoons, especially with the
many humorous incidents that occur. I
generally opt for a hardback A4 cartridge
sketchbook that I keep separately from my
normal sketchbooks unless it is a fairly short
trip, in which case I combine journal and
sketchbook in one.

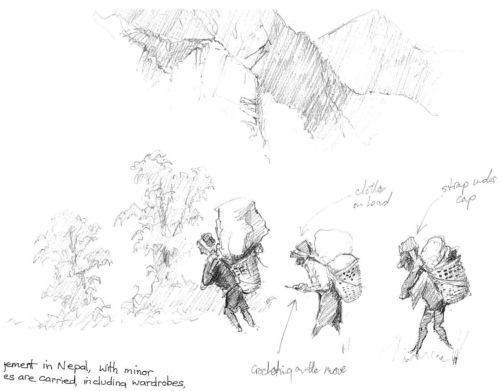

clothes
on head

strap under
cap

Crocheting on the move

Likir
Gompa

Likir
3500m

jement in Nepal, with minor
es are carried, including wardrobes,

Nepalese porters

DEMONSTRATION:
Mynydd Llangattock

22 x 32 cm (8 1/2 x 12 1/2 in)

On many gloomy winter days a marvellous sense of unity is evident, yet translating this into a painting can often result in a dire, foreboding work. The objective of this demonstration is to show how to retain the sense of unity, but also brighten up the image.

Stage 1
Selecting a sheet of rough paper, I began by wetting the sky and distant moors, then laying Naples Yellow over the lower part of the sky, with Yellow Ochre below, leaving the cottage, track and rocks as white paper. While it was all still wet I laid a fluid mixture of French Ultramarine and Burnt Umber across the top part of the sky, allowing it to seep slowly down the tilted painting. This mixture was prepared before I first wetted the paper. As it dried the granulations became more pronounced.

Stage 2
When the paper was absolutely dry I applied a weaker wash of French Ultramarine and Burnt Umber over the distant moorland ridge, again avoiding the building. More of the same wash was brushed across the foreground, including the track, to suggest depth in the picture.

Stage 3

To make the escarpment come forward I mixed Light Red with French Ultramarine, creating a warmer blue-grey colour. For the tree mass around the cottage the same mixture with added Light Red, was applied. When dry, some light-toned tree trunks were drawn in, again with the same mixture, using a No. 1 rigger.

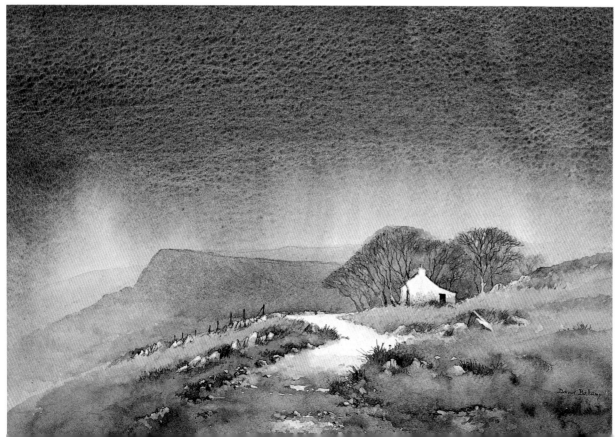

Stage 4 Finished painting

The darker trees and fence posts were described with French Ultramarine and Burnt Umber, together with some rock detail. I stroked across the mass of tree branches with French Ultramarine and Light Red using the side of a No. 4 round sable brush. For the foreground green I mixed French Ultramarine and Gamboge, leaving hard edges on the tops of rocks and stones. Cadmium Red on the door enhanced the scene with some warm colour. To complete the painting I laid a stronger wash of French Ultramarine and Burnt Umber across the foreground to make the track recede as it heads towards the cottage. The combination of white cottage, red door, yellow grass areas and light track all help to maintain a brighter image on an otherwise dismal day.

From scene to painting

Some artists prefer to paint their watercolours alfresco, some work solely from photographs. I work mainly from sketches done on the spot and backed up with my photographs, as this approach enables me to record scenes directly from nature, yet work in the comfort of the studio unaffected by climatic conditions or time constraints. Here we see a photograph of the scene and the resulting painting done in the studio.

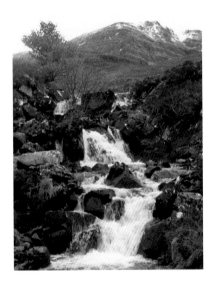

WATERFALL, APPLECROSS MOUNTAINS

WATERFALL, APPLECROSS MOUNTAINS
25 x 21 cm (10 x 5 in)

The mountains have been greatly subdued, almost lost in places. Being of Torridonian sandstone, a striking repetitive pattern covers the face of the rock, especially under a covering of snow, which highlights every rock terrace. Rather than render all that detail I elected to lose most of the face. The emphasis is therefore thrown onto the waterfall, bushes and rocks, but with the latter a little 'creative obfuscation' was necessary to lose the vast amount of rock detail, although it was all highly visible in reality.

Distant detail kept faint or subdued.

Hints of detail of vegetation rather than masses.

Hard edges on rocks in front of falling water.

Soft edges where water falls in front of rocks.

Details in rock lost in places to suggest it is 'growing' out of the ground.

David Bellamy

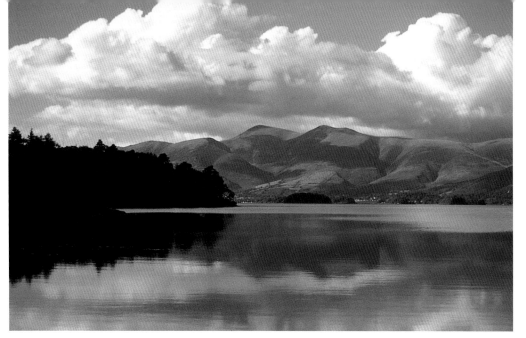

Simplifying the background

Skiddaw and Derwentwater

Let us try to be a little more creative with this scene, perhaps simplifying the mountain and bringing a little detail and colour into the great mass of silhouetted trees on the left, the only part of the photograph that tends to jar somewhat. The dark tree-clad island in the central middle distance breaks up the far shoreline well, but is it too far to the left? How can you improve the composition? My answer is on page 119.

Manipulating shadows

Old Palace, Leh

Many palaces and monasteries in Ladakh stand in the most imposing positions, and this photograph shows the Old Palace at the capital of Leh backed by stunning mountain scenery. Streamers of prayer flags run from flag posts to the palace. Use the cloud shadows to your advantage, both on distant mountains and around the buildings. By all means bring cloud down over mountain ridges if you wish to lose detail or break up a continuous ridgeline. Make the buildings look as though they are growing out of the rock. My effort is on page 120.

David Bellamy

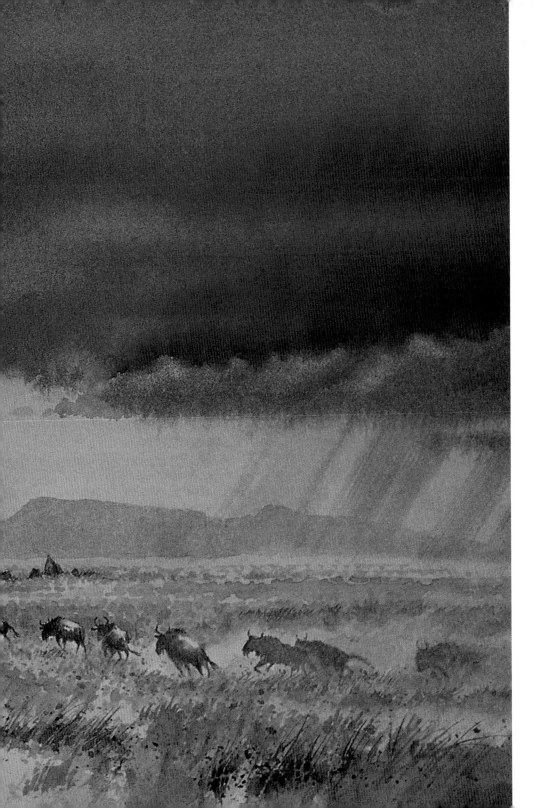

5
The Armchair Adventurer

The title of this chapter is not meant to refer to staying at home to paint, but to reassure those who are unable to hike off in search of wild scenery. Much of it is accessible to most people – from a car, a safari wagon, cable-car station, or even a hotel window. In the nineteenth century many well-appointed tourists and artists were carried to Alpine viewpoints in sedan chairs. Today there are less cumbersome ways to reach these areas. At some stage all of us make use of the splendid scenery that is often presented to us from out of the blue, whether by the roadside, on a train or even on coach rides. This is also an excellent way to collect subjects when with a companion who has little interest in painting.

SIMBA KOPJE WITH WILDEBEESTS IN FLIGHT
20 x 42 cm (8 x 17 in)

Wildebeests trailed all the way to the horizon. Nearby a male lion made a slight movement, causing some animals to panic and set off a stampede. Much detail is lost in dust, long grass and rapid leg movements. The sky was mainly painted using Indigo. Because of fine detail on the animals, I used 300 gsm (140 lb) Saunders Waterford hot-pressed paper for this watercolour.

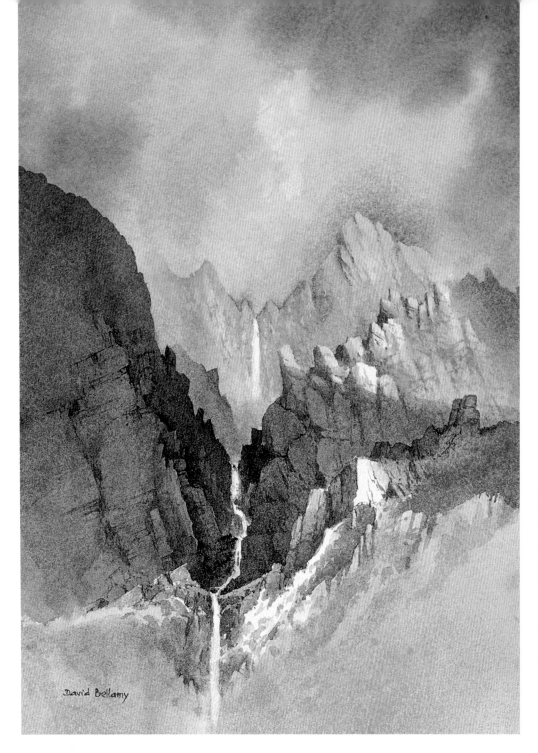

David Bellamy

Many elderly or infirm folk enjoy painting
mountains, and there certainly is no need to climb
them in order to create stunning pictures. Whether as a
backdrop to a lake, hill farm, or as a subject in
themselves, because of their size mountains can be
painted from many viewpoints. Some European
painters have even included jagged Alpine summits as
a background to the fields of Flanders.

Often distant views are more impressive, because
when you are close under the slopes acute
foreshortening distorts the perspective. Equipping
yourself with binoculars or a spotter scope, and, of
course, a telephoto lens on your camera, helps you to
study detail from some distance. I rarely carry a heavy
spotter scope around, but in a vehicle with a tripod it
can provide excellent close-ups, especially for wildlife.

Working from the car

We have all been caught out by bad weather while on holiday. Painting from the car then becomes more appealing, even if the high tops cannot be seen. Lakes, streams, bridges, trees, farms, cottages and such accessible subjects make splendid bad-weather options, with streams and bridges especially good even in the densest fog. For those who hate being accosted while painting, working from your car is an attractive proposition.

If you use a village or town where there are cable-cars and local transport as your base, often little more than a stroll is needed to find superb subject material. In many Alpine resorts one can enjoy morning coffee and an apple strudel while sketching distant peaks rising above the roofs. The cable-car at Vigo di Fassa in the Italian Dolomites, for instance, disgorges you into a lovely alpine meadow backed by some of the most stunning mountain peaks imaginable. In places like Petra in Jordan much of the scenery can be reached by pony, horse-drawn carriage, mule or camel, or you can climb a peak on a sure-footed donkey to sketch near the summit of a mountain. A camel provides a higher viewpoint, but a donkey is a more stable sketching platform. The Bedouin are extremely cooperative in these matters.

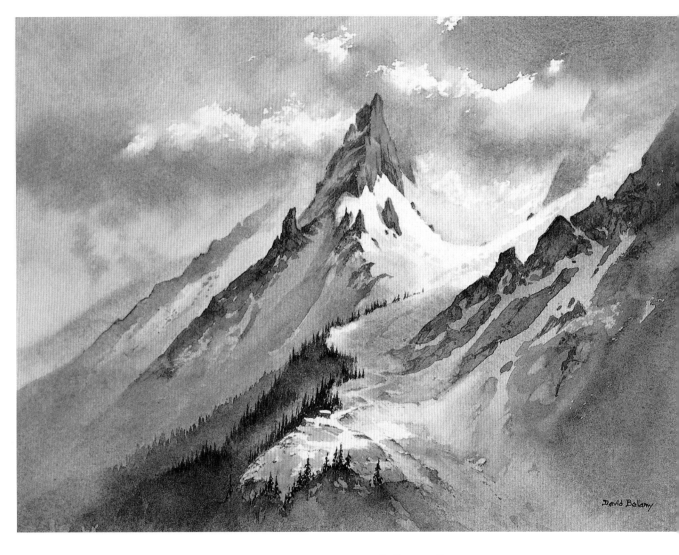

LA FLEGERE, CHAMONIX
19 x 26 cm (7 ½ x 10 in)

Here the peak itself is the centre of interest with a path leading upwards towards it, the role then taken up by the distinct ridge. Warm colours and strong contrasts emphasize it as the focal point, aided by losing adjacent peaks in the clouds. Many scenes like this are easily accessible from cable-car stations.

Mountains as a backdrop

Mountains, whether in the distance or more immediate, make superb backdrops to all manner of subjects. In this role it is best to keep them as free of detail as possible, even if you can actually see strong features. The observations of the Revd. William Gilpin written in the late eighteenth century for the benefit of travellers, though often bordering on absurdity, have interesting advice on this matter:

'With regard to mountains, it may be first premised, that, in a picturesque view, we consider them only as distant objects; their enormous size disqualifying them for objects at hand.'

In these two paintings the mountains have been treated slightly differently to illustrate possible approaches to the problem.

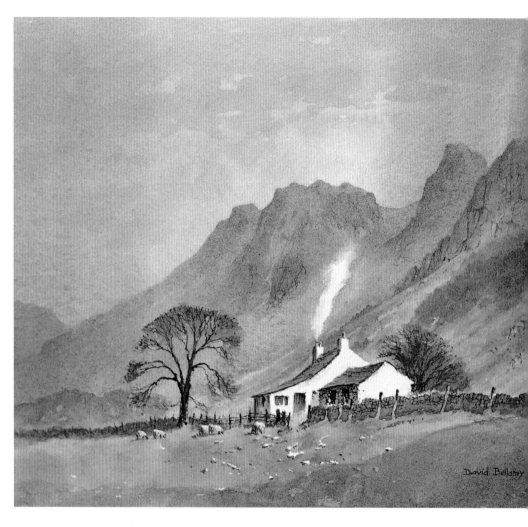

David Bellamy

BORROWDALE FARM (ABOVE)
16.5 x 22 cm (6½ x 9 in)

Here the background crags have been subdued of interest, with slightly more information on the closer crag to suggest depth, even though I could clearly see much more detail than indicated. Note the diagonal strokes of the brush on the slopes to suggest the gradient. I used Waterford Not paper for this painting.

SNOWDON FROM CAPEL CURIG (RIGHT)
20 x 28 cm (8 x 11 in)

By leaving the background mountains completely devoid of detail the emphasis is thrown onto the bridge and trees as the focal point. From this viewpoint Snowdon is often seen like this, although there is usually a hint of more detail. Too much, however, can reduce the sense of mood.

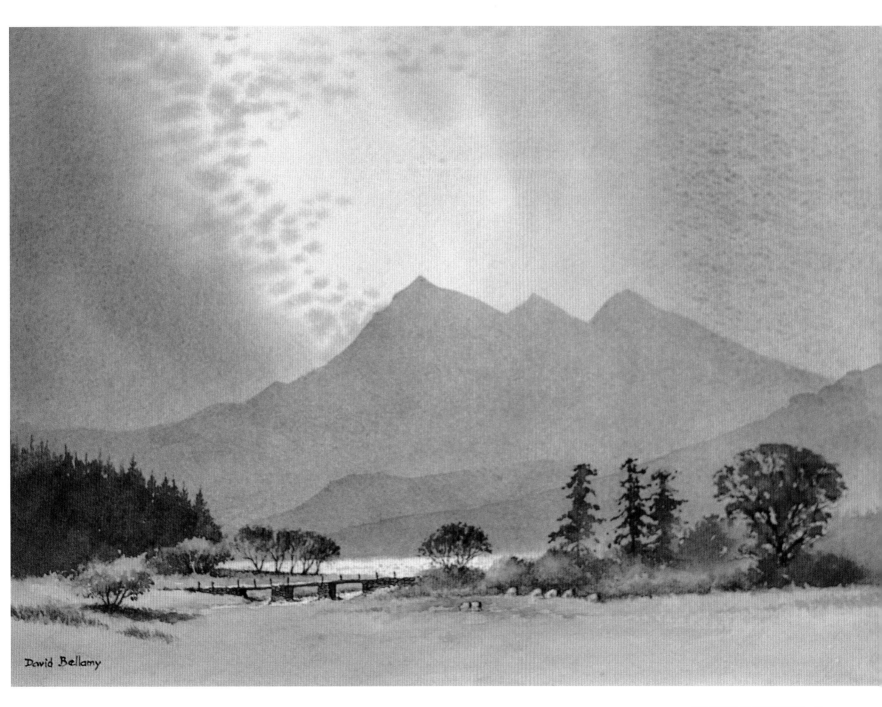

David Bellamy

Treatment of mountains

Whether working from a vehicle or by other means, mountains provide first-class subjects for the landscape artist. We shall cover many approaches to mountain painting in this book, but in every case we need to consider carefully how we wish to portray them. If the mountain is to be part of the background and subservient to a separate focal point you can simply render it as a flat wash, suggesting distance. Alternatively, you may wish to emphasize savage rock structures that almost threaten to engulf a dwelling, or perhaps less hostile gullies that thread a more gentle way down the face towards the focal point. In either case it helps to soften off the detail as it approaches the centre of interest. This can be taken further by introducing mist, shadow or a rain squall to obliterate part or most of the background detail. I shall be emphasizing this softening-off technique many times, as it is such a fundamental part of painting.

Where the mountain is to be the centre of interest itself, it is vital to consider which part should be highlighted – that is, which crag or, in the case of a large massif, which peak. Light and shadow play a major role here, and sometimes you have to wait for the right moment, especially when clouds are moving rapidly and causing shadow variations across the mountain face. It is worth observing the effects for a while to work out the optimum lighting. Note where there are hard and soft edges, but try to avoid too much confusing detail and too many razor-sharp edges, as it diminishes the overall effect. Complicated cliff faces can be deceptive to the artist, even in strong lighting, and on another day can appear totally different.

Rendering mountainsides

These examples give you ideas on how to render four common types of mountain terrain. All of them may well appear on a single mountain slope, but it would hardly be a good idea to include them all in one painting. Throughout the book you will find a wide variety of these features. It is well worth practising rendering these terrains separately on scraps of watercolour paper before attempting them in a finished painting.

Scree slopes
The easiest way to tackle a scree slope is with a dry-brush method, adding one or two larger rocks if required.

Gullies
Gullies can be defined by shadow and the angle of rocks and crags, kept consistent to reinforce the illusion of the direction of the slope.

Forested slopes
A mass of forested slopes is suggested by darker tree shapes in places, especially where ridges occur beneath the forest carpet, with individual trees where they thin.

Craggy ridge
Making a ridge appear as though it is receding involves the same rules as for a full landscape. Deeper tones, warmer colours and stronger features are used for the closer elements; less distinct for the distant ones.

DEMONSTRATION:
Loch Garry
21 x 32 cm (8 x 13 in)

The aim of this demonstration is to illustrate how simple variations in tones and colours can enhance a scene. Alternating cloud shadows with sunny slopes on the distant mountains adds more interest. This is also true of the loch itself where the reflections are strong in places and virtually non-existent in others, caused by the vagaries of the wind. This treatment avoids overlabouring a passage.

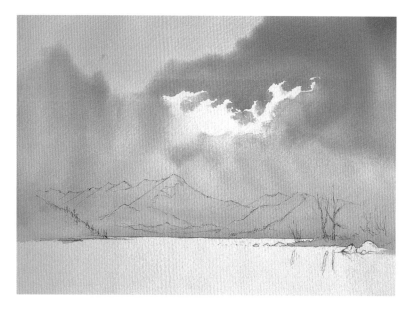

Stage 1
Masking fluid was applied to the trunks of the two birch trees. Some Naples Yellow was washed over the top of the sky and immediately followed by fluid Phthalo Blue (Green Shade) laid over the main part, working around the white clouds. Some weak Yellow Ochre was washed across the lower sky and with a damp No. 8 sable brush I softened the edges of the clouds away from the sunny side while the surface was still wet.

Stage 2
I painted Yellow Ochre with a touch of Cadmium Red over the left-hand slopes of the central peak, then a mixture of Phthalo Blue (Green Shade) and Cadmium Red on the distant right-hand mountain and some of the left-hand peaks. I softened the bottoms of these washes with a damp brush. Cadmium Yellow Pale brightened up the far shoreline just left of the birches. Before completing this stage I laid Naples Yellow and Yellow Ochre over the right-hand rocks.

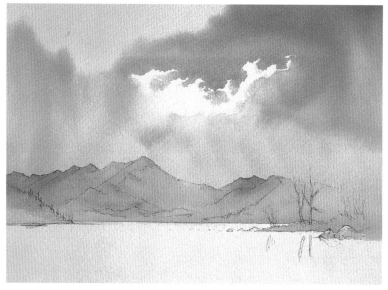

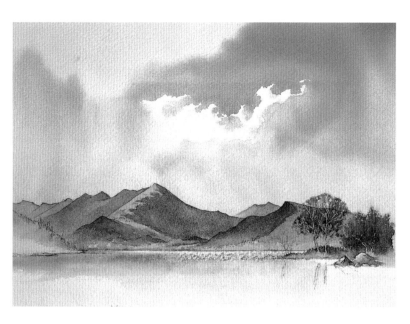

Stage 3

The peaks to the left of the main central one were painted with a mix of Phthalo Blue (Green Shade) and Cadmium Red, taking out a light patch in the col with a damp brush. Adding more Cadmium Red to the mixture, I applied it to the main peak, leaving the diagonal ridge running down to the left untouched. The same mixture was applied to the right-hand peak, then some Yellow Ochre was added.

I wet the lower part of the loch with clear water, then dry-brushed Phthalo Blue (Green Shade) and a little Cadmium Red across the further part of the loch, bringing it down to blend into the wet area below. I especially wanted to emphasize the right-hand side.

The shadow area on the right-hand peak was rendered with a wash of Phthalo Blue (Green Shade) and Cadmium Red. The right-hand trees were painted with Raw Umber and Alizarin Crimson, with Phthalo Blue (Green Shade) dropped in to suggest shadows.

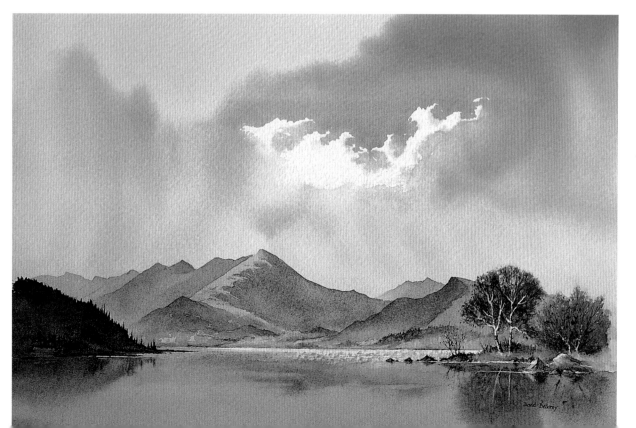

Stage 4 Finished painting

The left-hand tree mass of Phthalo Blue (Green Shade) and Cadmium Red had a little Yellow Ochre added, then tree detail was painted on the right with Burnt Umber and Cadmium Red for the branches. Finally, the reflections were suggested by applying strong colours into the wet wash on the loch and, while still wet, the lighter reflections of trunks were pulled out with a damp brush.

Perspective on natural forms

Many people encounter considerable difficulties in defining the perspective on water and crags. There is no magic formula, but the following examples will assist you in depicting these features in a reasonably realistic manner. Once you are well practised, of course, there should be few problems.

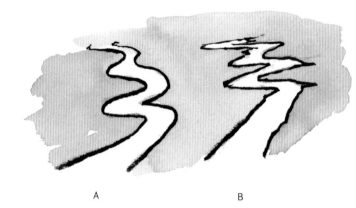

A B

Meandering river

Diagram A illustrates how a meandering river is often depicted by the inexperienced – it has a common width all along its length, making it look as though the viewer is hovering in a helicopter above it.

 The correct version is in Diagram B where the true width of the river is seen only when it is flowing directly towards the viewer, otherwise the foreshortening diminishes the width, so that it is often lost completely behind the bank or other features. This is a much more realistic view of a meandering river.

Perspective on lakes

Diagram A shows a common fault in painting lakes and the sea shoreline. It appears as though the artist is working in mid-air high above the lake. While that can be a useful technique on certain subjects, here it is disastrous. The shorelines are far too rounded for a normal viewing beside or slightly above the shoreline.

 Diagram B reveals a much better observation of lake perspective. The shoreline has been flattened out by the use of intermediate promontories, making it more apparent that the artist has his or her feet firmly on the ground.

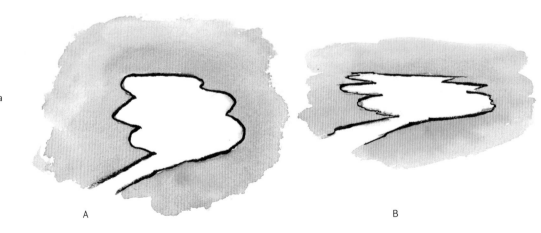

A B

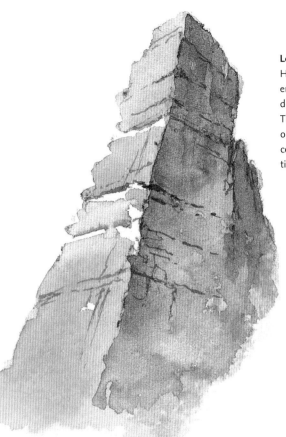

Looking up at crags

Here the natural fracture lines in the strata have been used to emphasize the sense of looking up at the crag by ensuring they slope downwards as they run away from the near corner, as with buildings. This effect can be suggested by rendering distinct strata and texture on the crag to conform in this way, although actual strata can, of course, run in any direction. Usually there is a pattern to it, and at times this is remarkably striking.

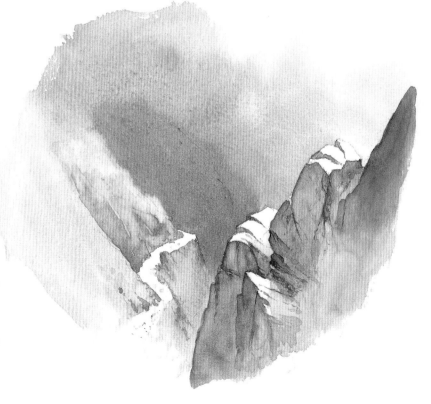

Looking down on crags

Note the importance of light catching the top of the crag and the angle of these tops, which sharply rise towards the distance. These aspects imply a strong sense of looking down on the crag. Although strata lines can be at any angle, unless they are at ridiculously exaggerated angles our eye automatically assumes them to be like any normal building structure.

DEMONSTRATION:
Hisley Packhorse Bridge
20 x 29 cm (8 x 11 in)

Painting 'wet-into-wet' is a powerful technique for suggesting out-of-focus background trees and vegetation in woodland or jungle scenes. By juxtaposing hard-edged foreground features against this soft background, a real sense of depth and atmosphere can be achieved. In this demonstration we see how effectively masking fluid can be combined with the wet-in-wet method to create these effects.

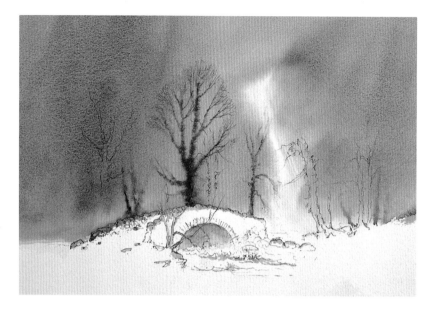

Stage 1

Masking fluid was applied to the bridge parapet, some rocks and the sapling. Then the whole area above the bridge was wetted with clear water and Naples Yellow applied to the right of the bridge. I mixed a generous pool of Davy's Grey with some French Ultramarine, then washed this over most of the 'sky', blending the colour into the Naples Yellow. While this was still deliciously wet a rigger was used to draw in hazy background trees with a stronger mix of Davy's Grey and French Ultramarine, thereby retaining a sense of unity. I laid some more of the sky mixture in the bridge arch, with Yellow Ochre introduced lower down. Note how important it is to maintain continuity between the background and the area beneath the bridge.

Stage 2

The masking fluid was removed from the parapet. Yellow Ochre with a little Alizarin Crimson mixed in was applied to the right of the bridge and the left-hand approach to it. To retain unity I painted the stream with Davy's Grey and French Ultramarine, leaving flecks of white highlights here and there, then I painted the left-hand parapet with Davy's Grey and some Yellow Ochre. I then began the central tree using Davy's Grey and Cadmium Yellow Pale. For the side of the bridge a wash of Davy's Grey was laid, then immediately splashes of Yellow Ochre, Cadmium Red and French Ultramarine were dropped in, leaving a few white areas.

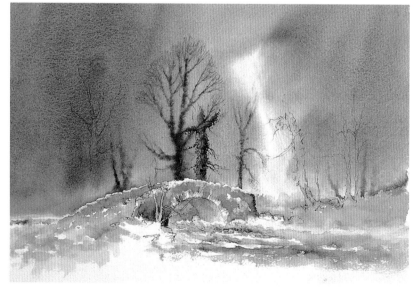

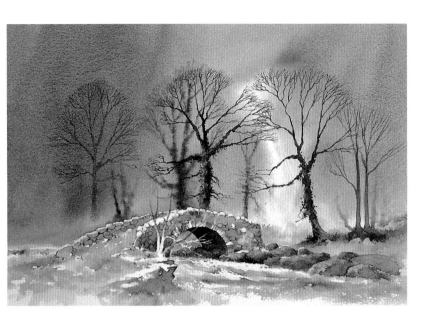

Stage 3
The remaining masking fluid was removed and more work was carried out on the trees. The left-hand tree was painted in lightly, then the rocks and dark trees on the right-hand side of the bridge. A strong mixture of Burnt Umber and French Ultramarine was applied to the underside of the bridge for the part in shadow, and detail described on the bridge structure.

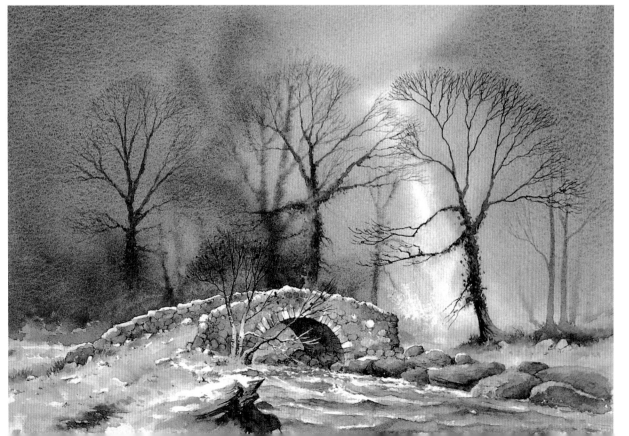

Stage 4 Finished painting
To strengthen the area above the bridge I re-wet it with clean water and applied a mixture of Davy's Grey and French Ultramarine, varying it in strength to create stronger darks in places. With a number 1 rigger I described the branches of the sapling in front of the bridge, thus helping to break the strong horizontal lines of the parapets, and I also added some Yellow Ochre on the lower part of the twin trunks. The painting was completed using dabs. I strengthened the water with French Ultramarine and Burnt Umber, using a No. 6 sable brush, blending the bottoms of each dab.

Painting reflections in a lake

The surface of large expanses of water is affected by wind, and its appearance can vary considerably across even limited areas according to the wind, current and amount of shelter available. Not only does the wind create ripples and larger waves when really gusting, but at times spindrift can be thrown high up into the air to create clouds of misty vapour. All this, of course, has a considerable effect on the reflections, and how sunlight sparkles on the surface.

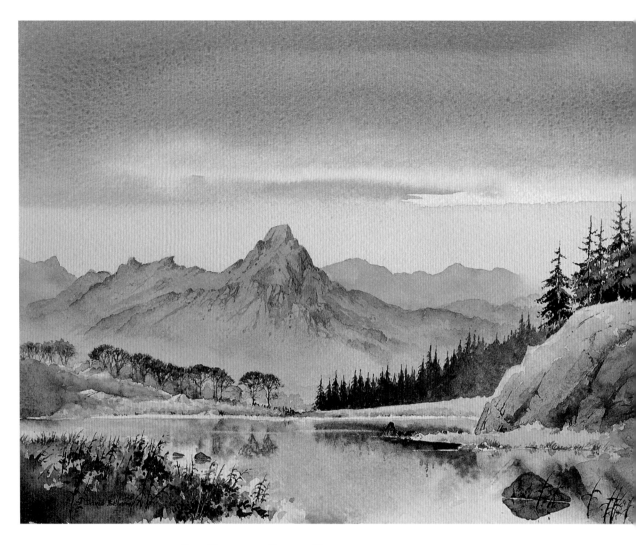

LLYN MYMBYR AND CLOGWYN MAWR
22 x 32 (9 x 13 in)

In this watercolour the lake has been painted with simple reflections. First I washed on an overall light blue-grey mixture of French Ultramarine and a touch of Burnt Umber. While this was still wet I applied stronger dabs of the same colours to suggest the dark tree reflections, with Yellow Ochre to reflect the far bank. I pulled out slivers of light water using a 12 mm (¹/₂ in) flat brush, working from the light side into the dark to avoid dragging out a dark line. If you find it too daunting to do both side reflections at one go simply concentrate on one side and let it dry. Then re-wet the other side, with a generous overlap onto the completed side, and apply the reflections when the moment is ready. This procedure will avoid panic.

Sketching wildlife

Wild animals make fascinating focal points and, while they can be sketched at a zoo, there is nothing like seeing them in their natural habitat. I could never have painted the animals in 'Simba Kopje with Wildebeests in Flight' (page 50) simply by visiting a zoo. Wildlife can also work well as a support to some topographical feature, such as a river, crag, kopje or trees. Working at length in a safari vehicle is only practicable if you have the vehicle to yourself, but it is possible to work up quick studies while with a group that spends time observing and photographing the animals. Game lodges are further possibilities for getting close to wildlife. Desert safaris by truck, camel or horse are also interesting possibilities.

While photography is an excellent way of obtaining studies of animals, only by drawing them directly from nature will you really master the subject. Fleeting studies of an animal can often say more about it than the most detailed photograph, and it is absorbing to try capturing their movement with pencil or brush. It takes imagination to avoid a wooden appearance when copying a photograph, whereas by striving to create an impression of moving legs a sketch can impart a greater sense of dynamism and action. You can further accentuate this by slightly blurring the background.

Much wildlife, however, can remain statuesque for some time, allowing you to capture their portrait reasonably well. You do need to persevere with many studies, abandoning the one you are working on when the pose changes and returning to it later, if possible. Do not expect too much of yourself at first. We all have many failures sketching animals, but every now and then it works, making the effort worthwhile.

LEOPARD IN THE SERENGETI
20 x 32 cm (8 x 13 in)

We stopped to sketch this young male leopard in a variety of poses for well over an hour and a half until he tired of posing. Our guide thought he had just been abandoned by his mother and was therefore a little disorientated. I have brought in the rocks from another location in the Serengeti.

JENNY SKETCHING FROM A SAFARI WAGON

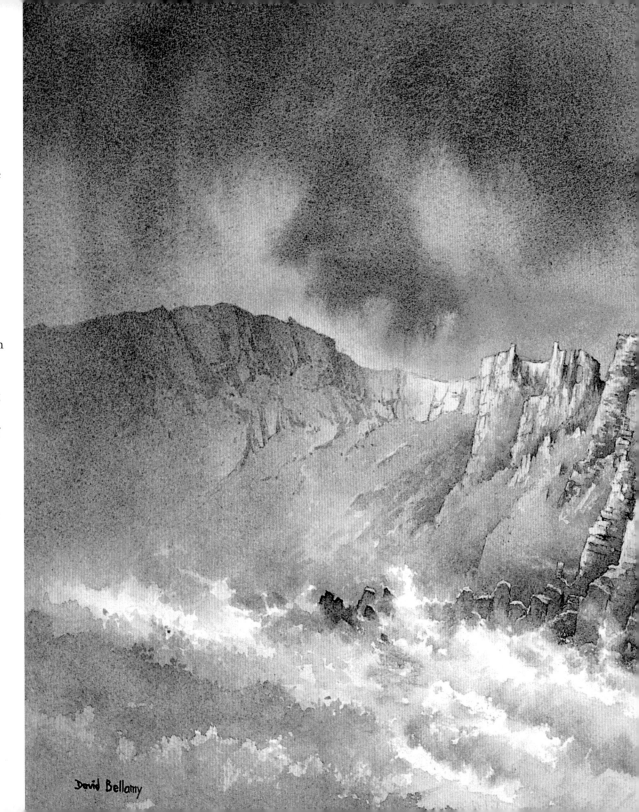

Wild coastal scenery

Rather than cover coastal scenery in depth here, I would refer you to my book on painting, *Coastal Landscapes* (HarperCollins, 2002). Much wild coast is easily accessible and can provide excellent opportunities for painting rock and cliff structures.

One of the most common problems in rendering large cliff faces is the amount of detail presented to the artist, so it is vital to seek out the more interesting features in the cliff and concentrate on those, playing down the less important detail. An extremely useful technique, if a little dangerous, is that of applying a wash of shadow as a glaze, over a painted area. The method will only work if the wash over which you intend to glaze has dried thoroughly before applying the glaze. Use transparent colours and as large a brush as possible, so that fewer strokes are employed.

David Bellamy

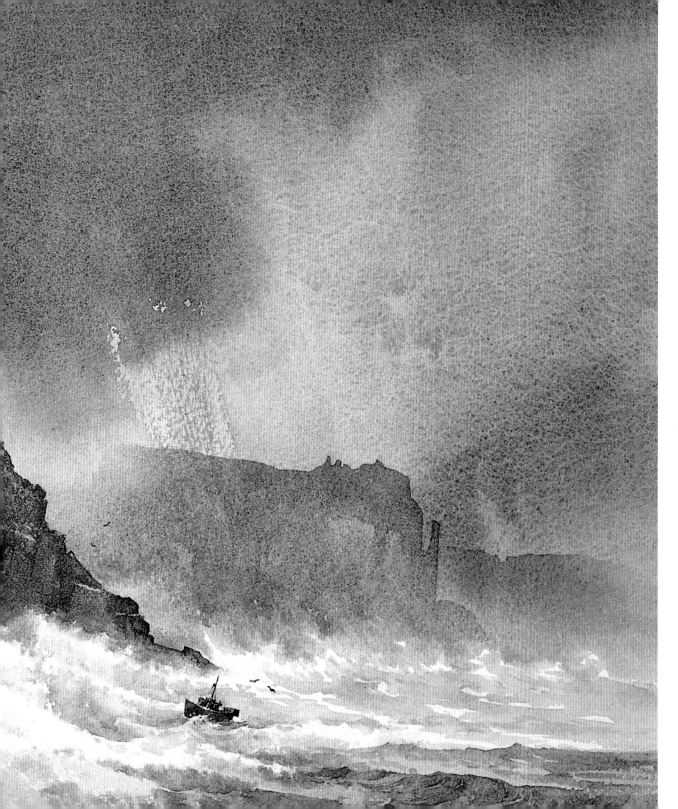

Eel Point, Caldey Island
30 x 51 cm (12 x 20 in)

With such intricate rugged
limestone cliffs it was essential
to concentrate on one part and
simply suggest the remainder,
completely obliterating some of
the cliffs in a fiery squall. The
fishing boat adds human
interest as well as a focal point.

Waves especially cause the artist problems, but if you begin sketching or painting them from a distance all the detail is subdued, making it easier. Gradually work closer. Build up the wave a step at a time, concentrating on one aspect of it, such as light catching the crest, for example, before moving on to render the cascading water and the manner it meets the surface below. Masking fluid can retain the light on crests of waves or splashes against rocks. Only hint at waves beyond the foreground one, otherwise it becomes too cluttered. Eventually you can get right in there with the wave to capture that lovely translucent effect of light filtering through a veil of moving water.

Amidst all this wild scenery – coastal, mountain, desert or wherever – are hidden away many gems that could hardly be described as 'wild' in the true sense of the word. Rustic old buildings, packhorse bridges, splashes of wild flowers, romantic castles – even rustic folk – all provide interesting material for the artist who does not wish to expend a great deal of energy in pursuit of subject matter. Many of these places are idyllic backwaters where we can quietly paint and immerse ourselves in a slower, more civilized way of life without having to exert ourselves unduly.

GREAT BLASKET ISLAND
In this rough sketch the jagged foreground rocks strike a sharp contrast with the misty island in the distance.

Changing colours

Sgurr Alasdair

This is a dramatic photograph of the highest summit of the Cuillin range, yet the sombre greyness needs much more in terms of atmosphere, colour or tonal variation. These peaks are reflective in strong light, so think about introducing some warmer colours in places, notably on the focal point. Would it benefit from a figure or two? Certainly the considerable amount of rock detail would be improved by simplification. My response can be found on page 116.

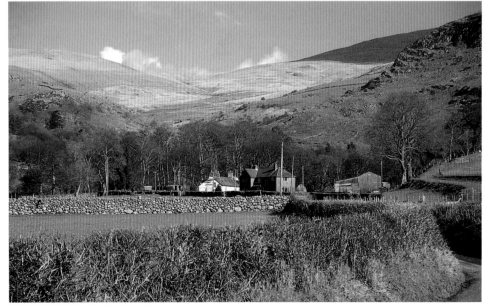

Being selective

Farm below Cadair Idris

Here we have a typical cluster of buildings in the landscape but, as so often happens, it is not ideally arranged to suit the artist. I find the white buildings attractive, with handsome chimneys, but lacking in doors and windows. Also unsightly scaffolding on the gable end casts odd shadows. I am not happy about the large drab-coloured house, nor the telegraph poles, and what should one do with the modern barn on the right? A distant hedge and the closer dry-stone wall add to our difficulties. This will undoubtedly call for a compositional sketch or two, so think about a lead-in to the focal point at the same time. Best of luck with the jumble in this photograph! You will find my attempt at this scene on page 122.

6
Into the Wild Places

Walking is a marvellous way of locating subjects, whether on day walks, staying overnight in huts, or backpacking. Take minimum materials, for it is so easy to overburden yourself with items you rarely use. Alpine huts, refuges, or bothies in the UK make welcome high-level accommodation breaks, often being subjects themselves, especially some of the simple Scottish bothies. Allow plenty of time to explore the surrounding area, for the huts can often be viewed from a number of angles for powerful compositions.

THE MATTERHORN
51.5 x 67 cm (20 x 26 in)

The interplay of sunlight and shadows in this watercolour on full imperial paper creates a moody atmosphere, accentuating drama. Although I could visualize this effect before starting to paint, I made a number of tonal sketches aimed at ensuring it would work in the painting. As well as suggesting mood, the soft-edged shadow over the lower part of the peak hides much unwanted detail and throws the spotlight onto the summit area. We camped at varying distances round the Matterhorn in an endeavour to sketch it from several angles. One night, woken during a snowstorm, in the light of a full moon, I made a watercolour sketch of it in my underwear and boots, the snow enhancing sketch and glistening long johns.

DAVID DESCENDING
INTO A CREVASSE TO
SKETCH AN ICE BRIDGE

METTELHORN, SWITZERLAND
A small watercolour sketch that betrays the wild weather. With the washes still wet, the image was reinforced with a black watercolour pencil – even if it rains these watercolour pencil images will remain, though the washes may well disappear.

Backpacking

Backpacking with tent or bivouac is more arduous, but you can stop wherever you like, within reason, and pitch camp. This also allows you to wait, days if necessary, for the mist to lift or rain to stop in order to get that view of the peak. Wild camping, even on a glacier, gives a sense of profound peace and tranquillity that is conducive to painting.

Sketching while backpacking in bear country can be a little hazardous, as animals approaching upwind may have no idea of your presence. This is particularly difficult near noisy streams, but so far, by singing 'Men

of Harlech' loudly, I have found most bears stay well away. Perhaps it has something to do with my appalling singing. This trick will rarely work with polar bears, though, because of the paucity of wildlife as food sources, so a sedentary artist can be a prime delicacy for lunch or dinner.

Spending a night out in a crack in the rocks on some wild mountainside, or just camping by a murmuring stream brings you more in touch with the earth than most Westerners ever experience.

PALE RABIOUSE, ITALIAN DOLOMITES
I used watercolour on this brief sketch to capture the evening colours on the crenellated ridges, spattering it violently at the end of my work. This seemed to entertain a group of German climbers who had stopped to watch proceedings.

Painting rocks

Rock scenery varies from cliffs, crags and boulders to loose rocks and stones, all made up of numerous types of rock. While it is not necessary to know the type of rock you are painting, it helps greatly to be aware of the various surfaces, textures, shapes and colours in front of you. Sandstone and granite formations tend to become more rounded with weathering, while limestone and Cambrian slate, for instance, are more angular, often jagged like teeth. This tendency is also marked in dry-stone walling, as the type of rock obviously affects the appearance of local buildings.

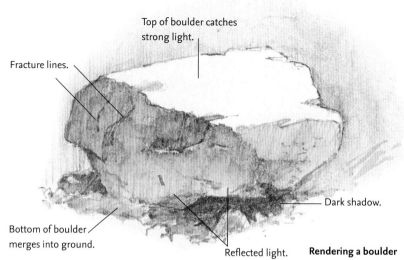

Top of boulder catches strong light.

Fracture lines.

Dark shadow.

Bottom of boulder merges into ground.

Reflected light.

Rendering a boulder
Rocks and boulders normally look best in sunshine. While this is generally also true of crag scenery, light mist will often enhance a crag, especially in separating it from a parent cliff, when in sunshine it can become confusing. This enormous boulder was drawn in intensely strong sunlight and reveals some interesting features that will help you in creating authentic-looking rocks.

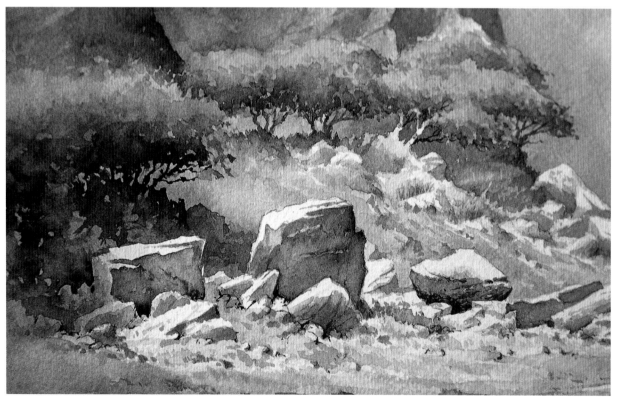

Painting sharp and round-edged rocks
Try not to over-elaborate by describing too many fractures and nicks in rocks, and note the various colours. Colours in rocks normally blend into one another, and the most effective way of managing this is to lay on a base colour and then drop others into it while still wet, as in those shown here.

Conglomerate

Conglomerate is not normally the most shapely of rock features, but with its multi-coloured fragments of embedded rock of varying sizes it has tremendous appeal to the artist who wishes to take advantage of colour and texture. It can be a licence to run free with the brush.

Limestone

This watercolour sketch of Shakespeare's Cave, Cwm Clydach, shows the dramatic and striking qualities of limestone, a rock that features caves, gorges, shapely pinnacles, natural arches, waterfalls and so much more. Limestone reflects light well and looks best in sunshine, which brings out its varied colours.

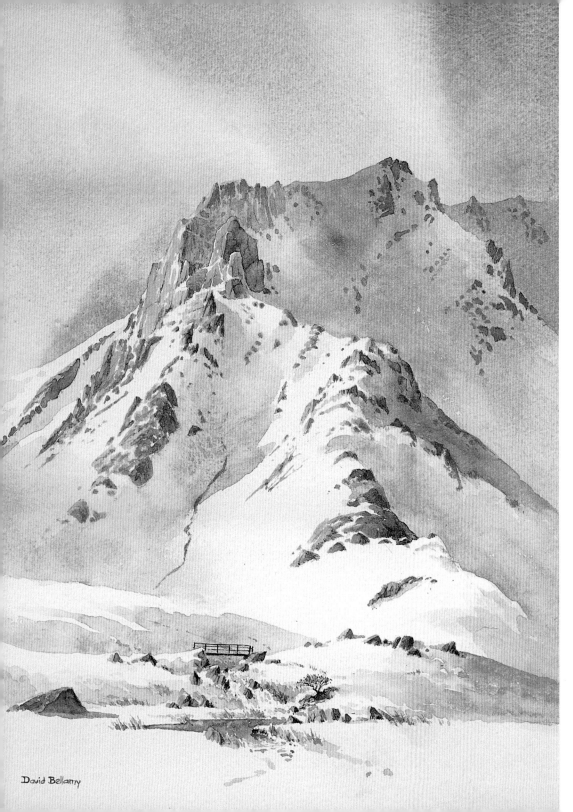

David Bellamy

Colours in rocks

In the wild places rocks are an important aspect of the topography. It is worth studying the various types of rock encountered, for their visual characteristics. Where there are distinctive and striking rock formations, this lends a strong sense of place to the location. Note also the wealth of colours in rock: study them carefully and you will find many subtle colour variations. In my early days my winter sojourns into the British mountains rarely saw the rocks at their best, with the lack of strong sunlight. The overcast sky usually reduced the scene to a dull monochrome, often exacerbated in snow conditions. When I began painting in the Italian Dolomites, with their warm and brighter colours, my whole outlook on painting rock scenery changed and my work became more colourful, even on a dour day in Blaenau Ffestiniog.

On colourful rocks I paint directly with reds or Yellow Ochre, for example, although on less brightly coloured rock structures I usually paint a light grey first, immediately dropping in one of the warm, bright colours and letting it drift across the wet area. Needless to say, you can only render a few rocks at a time, otherwise the first ones will already be dry when you apply the additional colour. In shadow areas I prefer to use the latter method.

Castell y Geifr, Snowdonia
33 x 24 cm (13 x 9½ in)

Morning sunlight catches the crags, while much of the mountain is cloaked in cloud shadow. Snow scenes are notoriously difficult in flat lighting, as it is almost impossible to make out the contours and ridges in places. The stream flowed away to the right, hidden by rocks and snow banks, but it is easy enough to create a lead-in up to it by suggesting a channel or track in the snow, or bend the stream itself.

Heightening mood and drama

Colour affects the mood of a place, but at its best the colour needs to be kept within a harmonious range to achieve a sense of unity. One powerful technique to create overall harmony in a painting is to flood a transparent glaze across the work. This brings any varied colours into a more harmonious whole. You will need to use as large a brush as possible – the fewer the strokes the better, as you are then less likely to disturb the underlying washes. By limiting the number of colours you use, a greater sense of mood is achieved.

The mood of a painting is additionally affected by compositional structure. To emphasize tranquillity, include more horizontal features. For a more dramatic atmosphere, accentuate the verticals.

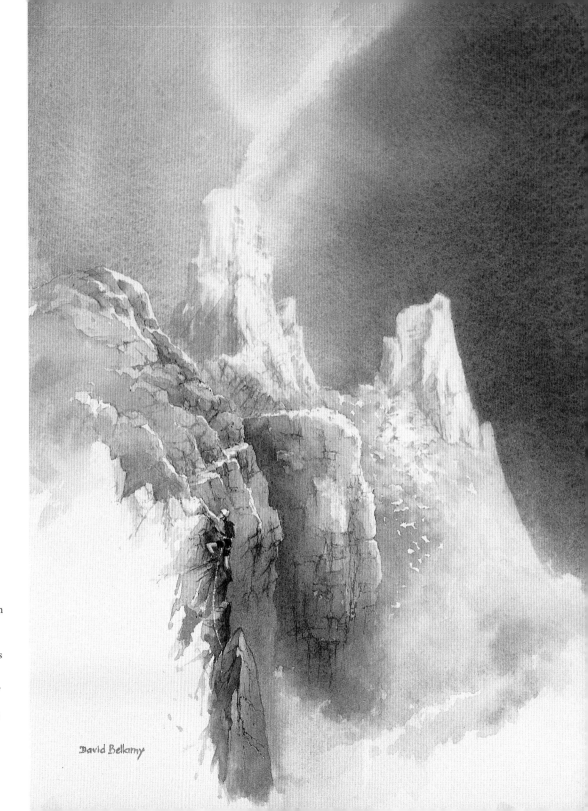

MASARE RIDGE
26 x 18 cm (10 x 7 in)

Shimmering Gothic spires of Dolomitic limestone gleam out of background mist, in an arena that demanded gymnastic sketching. The vertical cliff up which my daughter Catherine is climbing emphasizes the drama of the situation. A storm was about to engulf us in this exposed position, but I resisted the temptation to include it this time. The sharper foreground crag has been vignetted to avoid over-elaboration.

DEMONSTRATION:

INGLEBOROUGH

22 x 31 cm (9 x 12 in)

Snow has the lovely effect of hiding unwanted detail on the ground and highlighting winter trees, but unless you introduce warm colours snow scenes can often appear cold, flat and lifeless. This painting shows how we can liven things up. The watercolour was carried out on Waterford rough paper.

Stage 1

First I mixed a pool of Indigo and Permanent Rose. Then, after completely wetting the paper, I laid the wash across the sky, leaving large areas untouched. The wash was brought down over where the mountain would appear because the mountain would be darker in tone – note that I planned this before picking up a brush. In the lower right side of the sky some Permanent Rose was drifted down below horizon level and a little Cadmium Yellow Pale dropped into the top part of this passage. Gradually the white areas diminished as the washes spread, leaving only a few bands of soft-edged white as intended. It is worth comparing this sky with that of 'Mynydd Llangattock' on page 47, for there is no granulation here as there is in the other painting, because of the different colours used.

Stage 2

For Ingleborough mountain I painted a wash of Indigo and Permanent Rose, with a dash of French Ultramarine to add a little blueness. I used sweeps of dry-brush curving downwards, leaving a white band sloping towards the barn to help draw the eye to the centre of interest. The top left edge of the peak has been faded out as it approaches the edge of the painting – ridges can look monotonous if left the same all the way along. The walls and barn were painted with Indigo and Raw Sienna, and the Swaledale sheep in the foreground with Raw Sienna and Naples Yellow.

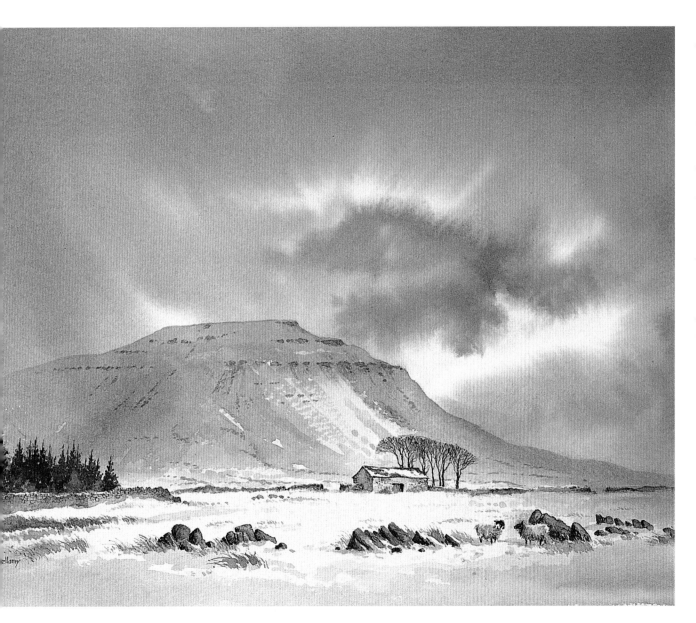

Stage 3 Finished painting

The crags punctuating the mountainsides were rendered in Indigo and Light Red, as was the shadowed gable end of the barn and the foreground limestone outcrops. Cadmium Yellow Pale was mixed with Indigo to produce the green for the left-hand conifers, which were brought down just short of the dry-stone wall to suggest snow on the top of it. I drew the trees by the barn with a mix of Indigo and Light Red using a fine rigger. I completed the sheep and other foreground elements with a fine sable brush.

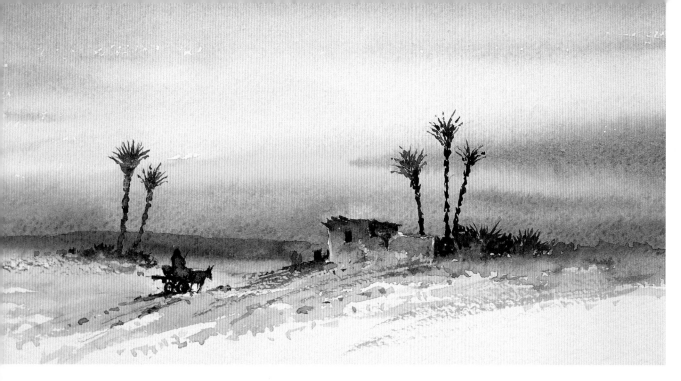

APPROACHING FARAFRA OASIS, WESTERN DESERT

16 x 30 cm (6 x 12 in)

This rapid watercolour sketch on rough paper was carried out at dusk. The sky was continually changing, so I kept it simple as I was more concerned with the mood than with intricate detail.

Painting in the desert

The desert poses a number of problems for the artist working on location – paramount, of course, being that of coping with intense heat. Methods to reduce the speed of drying include putting a drop of glycerine in the painting water, using a rough watercolour paper, laying a wash of clean water across the paper before applying the actual wash, and, of course, keeping the work out of direct sunlight if possible. Beware of dropping in too much glycerine, though, otherwise the watercolour might well take a fortnight to dry! Harsh sunlight can seriously affect your value judgements and the tendency is to paint with too strong a tone, so some adjustment may be necessary.

In the desert skies can be something of a problem, when day after day reveals flat, blue skies with not a cloud in sight. A light, fluffy cloud or two can be helpful in breaking up the monotony without really affecting the ambience of the day. Consider graduating the tone across or down the sky, or introducing hints of other colours. A drastic change by bringing in a much warmer and stronger colour such as in 'Desert west of Al Fayoum' on page 82 can work wonders and alter the mood. Take advantage of any wild skies or desert storms as these can add considerable drama to a desert painting. Two outstanding Orientalists, Robert Talbot Kelly (1861–1934) and A.O. Lamplough (1877–1930) specialized in desert scenes that invariably included simple, yet gloriously effective, skies in their watercolours, and are well worth studying.

Desert scenes often call out for the inclusion of figures, and traditional Arab dress certainly adds colour and a flavour of the east to the work. I tend to include a higher ratio of figures in my desert paintings than in others. The best figures are those who are actually doing something, rather than just standing around like models. This treatment can suggest a story unfolding, especially by including gestures to suggest anger, pathos, delight, and so on.

BEDOUIN TENT, UM ULAYDIYYA

29 x 47 cm (11 x 18½ in)

So often we choose to visit a part of the world because of its outstanding topographical features, yet time and again, even for us dyed-in-the-wool landscapists, it is the local people who make the strongest impact on us, and not just pictorially. Those of us who work in the mountains and deserts are lucky in that there is generally an abundance of characterful figures around. In developing countries women in particular tend to wear more traditional clothes, providing excellent sketching opportunities. Many are happy to pose for a small consideration, and some go out of the way to ask for their portrait to be done. If they are really superb subjects I often do at least two portraits and give them one.

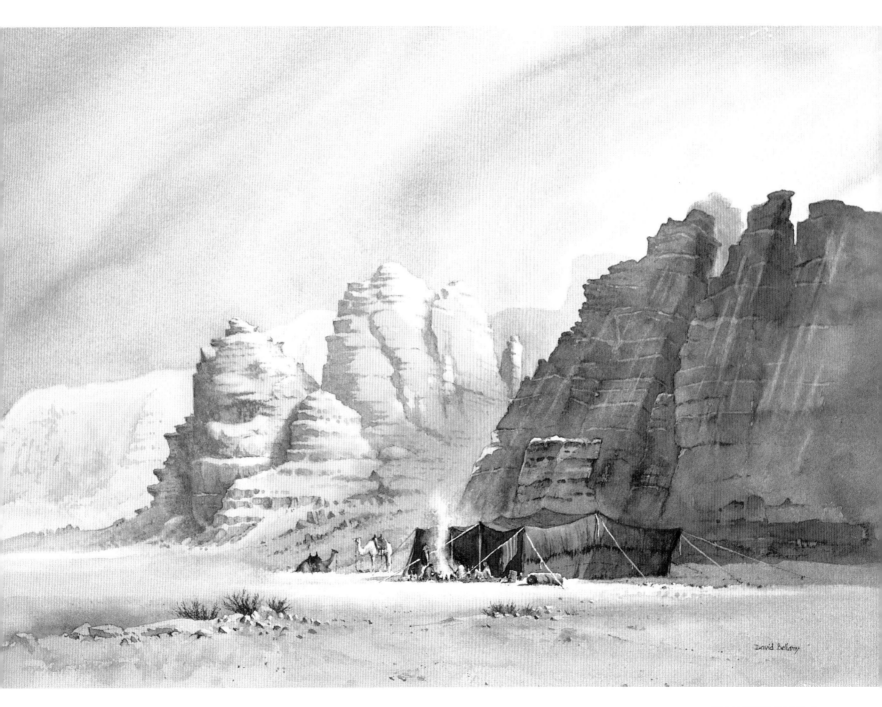

David Bellamy

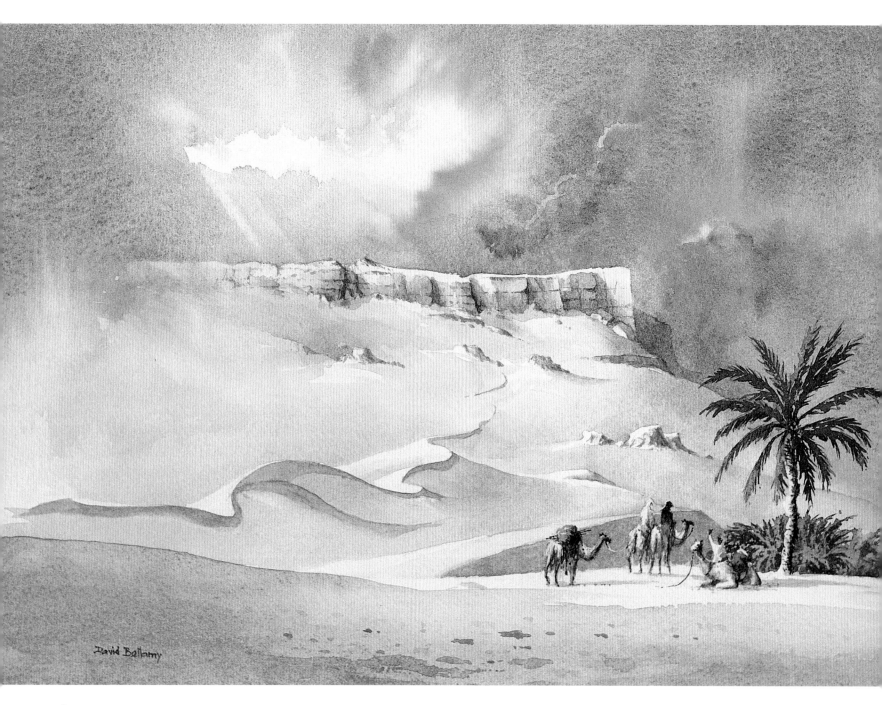

David Bellamy

ANDEAN LADIES IN THE SANTA VALLEY, PERU

The local ladies in this area wear colourful garments, adding wonderful splashes of colour to town and village scenes. Their heads seem slightly larger in proportion to their bodies than most races. Pencil and camera had to be ready at a moment's notice for some characters were quite unexpected, including a lady taking a pig for a walk on a lead.

SIGN AT NAMCHE BAZAAR

Mordern Hairdressar
न्यू मोईन हेयर ड्रेसर
Ladies And zens, Namche Bazaar

DESERT WEST OF AL FAYOUM, EGYPT

23 x 31 (9 x 12 in)

The sharply etched switchback ridge of dunes leads up to the crags, which I have illuminated with a violently warm sky. Naples Yellow formed the majority of the sand, sometimes with a little Permanent Rose added.

A sense of scale

Whether in the desert, mountains or plains, where it is important to give an idea of the size of a mountain, crag, gorge or large feature the introduction of figures, animals, trees, buildings or vehicles can be helpful. It is preferable not to position them too close to the foreground, otherwise they dominate the composition. Figures and animals are probably most appropriate with the smaller crags, gorges and icebergs, and in keeping with the relative sizes. It is worth trying out different sizes of figures in a painting, from being almost imperceptible to quite large, to see the effect each size has on the scene. Use non-staining colours, as they can immediately be washed away with a wet brush if you are unhappy with the result.

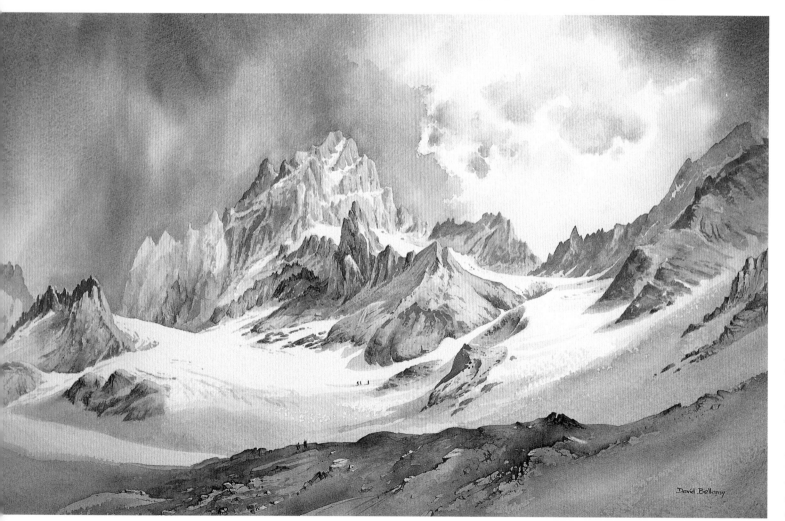

GLACIER DE LA GRANDE RUINE
30 x 47 cm
(12 x 18½ in)

Figures not only immediately draw the eye as a centre of interest, but give a powerful sense of scale, especially when positioned some way into the distance.

Snow-clad mountains

Often on expedition we have climbed from arid desert or dense jungle up to high altitude when, naturally, the temperature plummets. Our tropical shirts and sun-hats are exchanged for duvet jackets and woollen hats as we approach the snowline, with its new set of challenges. Snow on rocky mountains creates stark imagery on rock faces. There is a definite structure to this, and you would do well to avoid vague gestures. Snow rarely stays for long on near-vertical rock, so a clear-cut pattern emerges of it lying in gullies, cracks, ledges and the gentler slopes. It reveals the strata in cliffs and rock scenery clearly. Note the structure of these patterns.

Where the scene encompasses large snowfields, vary the colour and tone of the snow rather than create a lifeless mass of white. The colour of snow is affected by light and shadow, so subtle changes occur when the angle of the slope varies or it comes into contact with another feature. Naturally the general colour of the sky also affects areas of snow. These areas can be broken up by rocks, vegetation, tracks, cast shadows or sastrugi ridge patterns, but take care not to overdo this, otherwise it will look laboured.

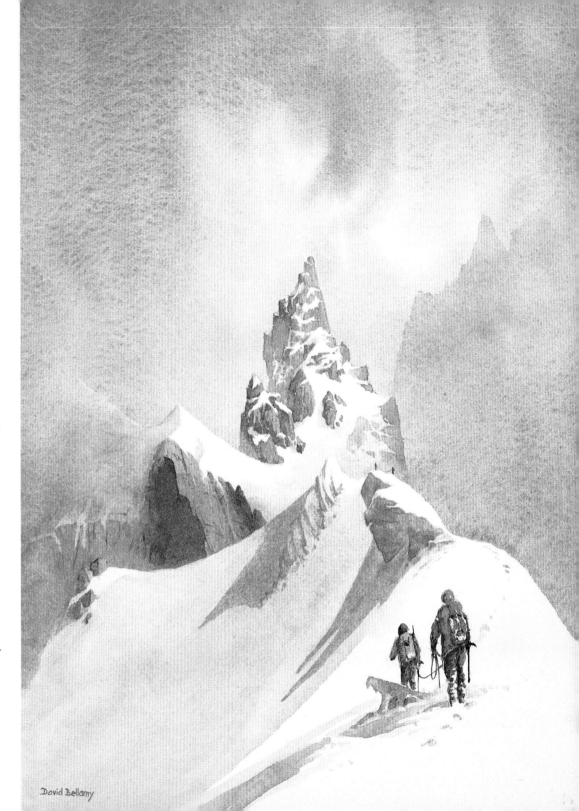

DENT DE REQUIN

32 x 24 cm (13 x 9 in)

The two pairs of figures afford a sense of narrative to this scene – as the weather starts to close in are they aiming for the summit of the peak or on their way down? The foreground pair gives a sense of colour to a painting otherwise lacking in colour, while the distant pair highlight the enormity of the Dent du Requin by their miniscule size.

David Bellamy

Snow and ice on cliffs

Many artists encounter difficulties when trying to depict snow lying on cliffs and steep rock-strewn ground. The simplistic approach of flinging dark and white tones around willy-nilly is unconvincing. There is a definite structure to the manner that snow lies on this savage rock architecture.

Snow does not normally stick well to vertical faces, although there are exceptions at very high altitude. A false perception is built up by the fact that moderate snow-bearing slopes can appear as almost vertical faces when seen from certain positions, such as directly opposite but some distance away. On these two pages we examine snow lying on steep mountainsides.

FROZEN CASCADE, GLENCOE
In places surprisingly vivid colours get trapped in the ice. Cascades and waterfalls petrified by ice usually display fascinating shapes and tones.

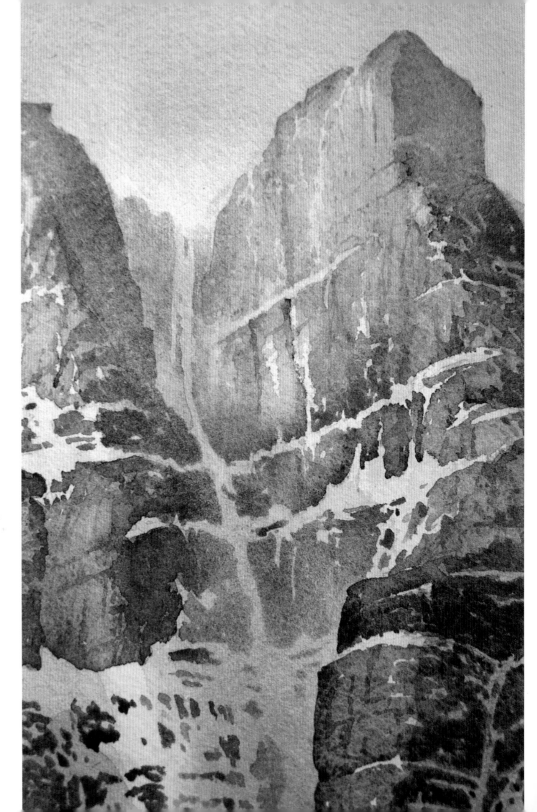

SNOW PATTERNS ON TORRIDONIAN SANDSTONE
Note the manner snow clings to ledges and crevices. Torridonian sandstone presents a complicated pattern of detail, a great deal of which is best lost in mist or shadow.

STORM POINT, WYOMING

28 x 23 cm (11 x 9 in)

This shows only a small part of the Grand Tetons massif, but illustrates examples of how snow relates to various mountain features. Shadows applied with French Ultramarine relieve the flatness and bring life to the scene. Strong cast shadows would have further enhanced it, but I wished to retain the cloudy mood. It is worth applying a shadow of blue, blue-grey or mauve in this way, even when you cannot see such.

Shadow here emphasizes the narrow gully.

Note the way cliffs rise out of steep slopes and thus how snow accentuates this.

Make the most of snow lying on ledges and flattish surfaces, but do not overdo the effect.

Most of the snow here has melted because of exposure to sun.

This shadow helps indicate the steepness of a gully and that it is hemmed in by dark cliffs.

David Bellamy

DEMONSTRATION:
EVENING GLOW, VALLÉE DU MARCADAU
22 x 32 (9 x 12½ in)

Warm evening light can flood a scene with a powerful sense of atmosphere and unity. Creating that mood is the main objective of this demonstration.

Stage 1
The Not paper was wetted down to the top of the river, then a series of bands of colours applied horizontally across the sky with a squirrel mop brush. Across the top is Alizarin Crimson, lower down Cadmium Orange, and in the lower sky weak Naples Yellow to create a glow.

Stage 2
When the paper had dried I laid fluid Alizarin Crimson over the peaks, and immediately dropped some French Ultramarine into the wet wash, but leaving the left-hand sides of the peaks alone to suggest light coming from the far left. Some Yellow Ochre was laid across the lower part of the picture, allowing it to drift up into the wet wash above, to avoid hard edges.

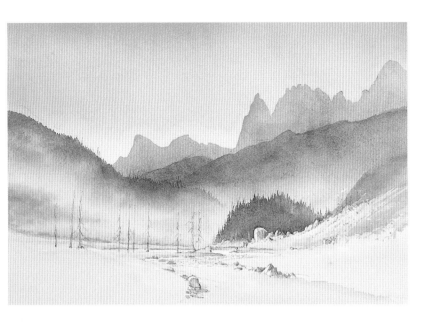

Stage 3

The intermediate ridge was painted with a mixture of French Ultramarine and Cadmium Red, applying it with the side of the brush on the right where I wanted a softer edge. The river was painted, reflecting the sky colours. I defined the forested ridge above the foreground pines, bringing the wash down into a wet area to create a feeling of mist. This was done with a small squirrel mop with a sharp point to create the massed conifer effect. For the forested hill French Ultramarine, Cadmium Red and a touch of Yellow Ochre was brought down to the top of the field of light-coloured boulders.

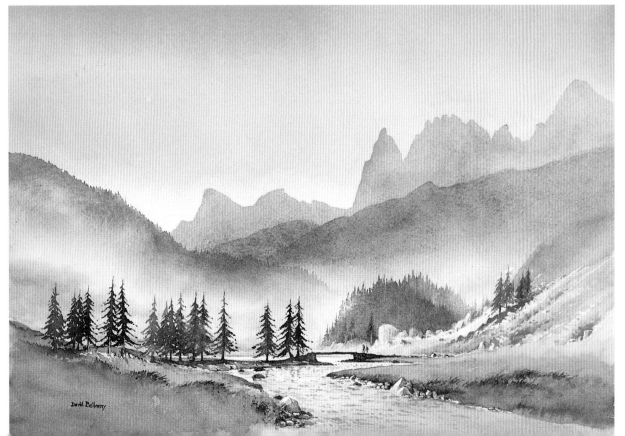

Stage 4 Finished painting

I drew in the bridge and tall conifers with Burnt Umber and French Ultramarine, and washed over the foreground with French Ultramarine and Cadmium Yellow Pale. Some dabs into the river with a No. 4 fine sable brush to give the impression of rippled water completed the painting.

David Bellamy

Painting trees

Single trees, or those at the edge of a group, are, of course, not just useful to provide a sense of scale, but also support a focal point or frame a feature within the composition. Massed trees and forests with a confusion of amorphous detail are best tackled by picking out those parts that excite you most, and you can emphasize them with strong tonal contrast, brighter colours and greater detail. One detailed tree supported by one or two less detailed ones, while understating the background, is usually sufficient.

As with all types of subject, avoid having too many competing features. Wet-in-wet technique is especially effective in suggesting a background of hazy trees or jungle, allowing a strongly detailed focal point to stand out. Bright and exotic jungle colours also sit well against a wet-in-wet soft-focus backdrop. The painter Edgar Degas (1834–1917) said, 'A painting requires a little mystery, some vagueness, some fantasy.' In forest and jungle you can let your fantasies run wild.

Massed conifers
Do not try to define every part of every tree. Pick out a few important examples with subtle detail, and simply suggest the rest.

Lether Tor, Dartmoor
21 x 31 cm (8 x 12 in)

The interplay of shadow across the face of this shapely tor adds interest, while the right-hand trees act as a repoussoir, framing and pushing back the main feature and relieving the overwhelming rocky composition.

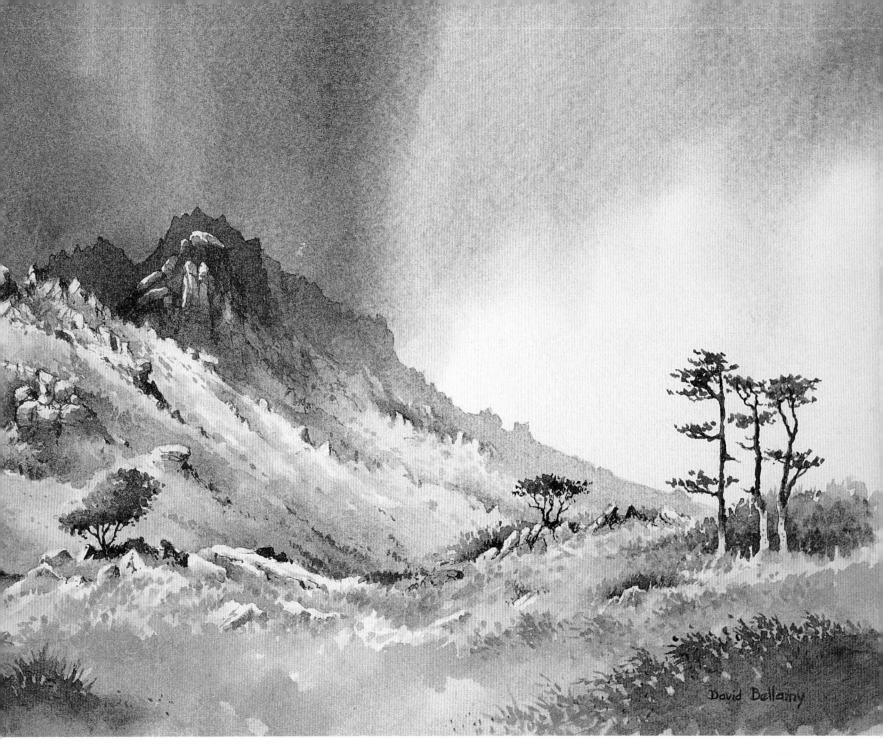

David Bellamy

**JUNGLE TRAIL IN THE
CORDILLERA BLANCA**
23 x 21 (9 x 8 in)

Painting in jungle is very
much like forest work, only
there can be colourful and
exotic plants to act as a
centre of interest. The
bromeliads with their violent
reds and yellows draw the
eye in this scene, contrasting
with the hanging glaciers
hovering above the jungle in
the distance.

Emphasizing mood

Gaube Vallée and the Vignemale (left)

The Vignemale is just appearing at the top right of the photograph and I carried out a number of sketches of it as we climbed in intense heat. As so often happens, we are presented with a magnificent scene, yet several problems need to be addressed. First, the river is broken by long stretches of intervening features, then the tree cover inhibits the eye from arriving at the mountain peak; thirdly, we would benefit from seeing more of the peak. A storm was threatening, so the light has become rather flat – can we enliven it a little? Finally, look at all that foreground detail. Do we really need all those boulders and stones? The challenge is yours. See my painting of it on page 123.

Focusing on the important features

Scwd Cil Heptse (right)

The light is fading on this scene photographed in the Brecon Beacons and much colour in the rocks next to the white water has been lost. Think about adding more colour and simplifying matters a little. Is this the right format for the painting? You may prefer to take just part of the falls, rather than paint the whole course. My version can be found on page 124.

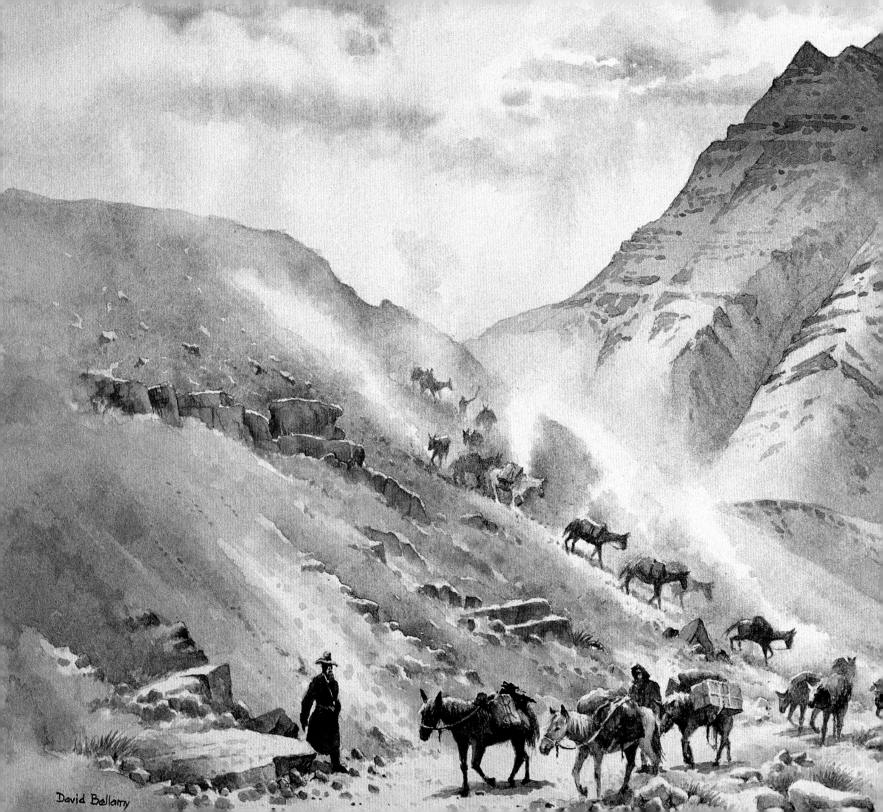

David Bellamy

7
Expeditions and Wild Stuff

While there may not be hordes of artists who wish to squirm through caves encumbered with sketching apparatus, climb high winter mountains or plan expeditions to remote places, such images appeal to many, even if they feel reticent about indulging in these delights. For those who prefer not to expose themselves to risk, discomfort, danger, hardship and the agues, much can be gained by studying some of the features described in this chapter. If you are painting simply for your own enjoyment you may well feel that it hardly matters if you are doing it secondhand.

Packhorse train, Ladakh
30.5 x 40.5 cm (12 x 16 in)

This was part of the packhorse train carrying our tents and equipment across the mountains in between campsites. My object was to put across the intense heat and vast clouds of dust that accompanied the animals. To the enlightened artist clouds of dust are a godsend, because they create strong atmosphere and lose superfluous detail. Several sketches and photographs assisted me in constructing this work, as each horse had to be individually thought out, yet blended into the whole.

SKETCHING AMA DABLAM ON TREK
Mingma, the deputy cook, took great interest in our painting. We encouraged the Sherpas to sketch at every opportunity.

Trekking

Trekking expeditions are an extension of what we covered in the previous chapter. These can last from one day to as long as you wish. Trekking in developing countries has many advantages – paths are usually good and the cost of porters, guides, pack animals and support is relatively cheap. To be able to walk through mountain ranges with new scenery unfolding day after day while all your gear is being carried for you is extremely liberating. When places like Everest, Machu Picchu, Jebel Toubkal and so on are involved it becomes spectacularly uplifting. Having expedition cooks and folk to erect and strike the tents means you can concentrate more on the painting, though this service sometimes reaches heights of the ludicrous.

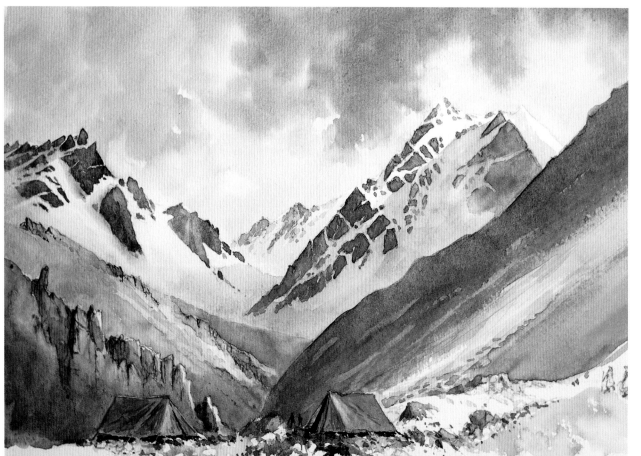

CAMP BELOW STOK KHANGRI, LADAKH
23 x 34 cm (9 x 13 in)

This watercolour was painted on the spot after a long climb to 4,800 metres (16,000 feet), with the sun beginning to dip behind the mountains.

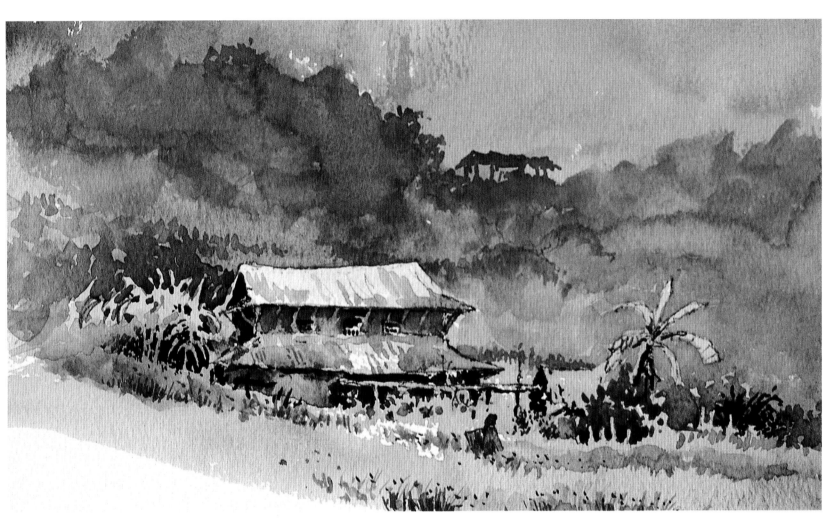

Sherpas have rushed out of camp to bring me a chair or welcome drink while sketching! But simply being with these people is a great joy, for often their friendship transcends the beauty of the mountains.

With pack animals I tend to carry a wider range of art materials, but the most vital items I keep with me in a day-sack, for we have had horses bolt when crossing a river in the Andes – it's rough if they take off with your knickerbockers down river or over a vertical drop, but a disaster if sketchbooks exit by the same route. Yaks can betray an occasional vicious streak when those lethal horns cut through backpacks and tubes of paint like an arrow. One of our Sherpas once had a yak horn through his shoulder, but he recovered after treatment. Yaks will eat anything, and one of our trekkers had the misfortune to see an enormous yak enthusiastically devour his watercolour sketch of Everest, which he had left on a wall to dry in the sun!

MILLET TERRACES, ANNAPURNA FOOTHILLS
In this outdoor sketch the heat created problems with the washes drying quickly, as can be seen from the messed-up wooded hill and sky. Lower down I began with a wash of water first, rectifying the problem. Note the extensive use of the negative painting method on building and vegetation. The lady, appearing out of the high millet with her basket, adds a little colour.

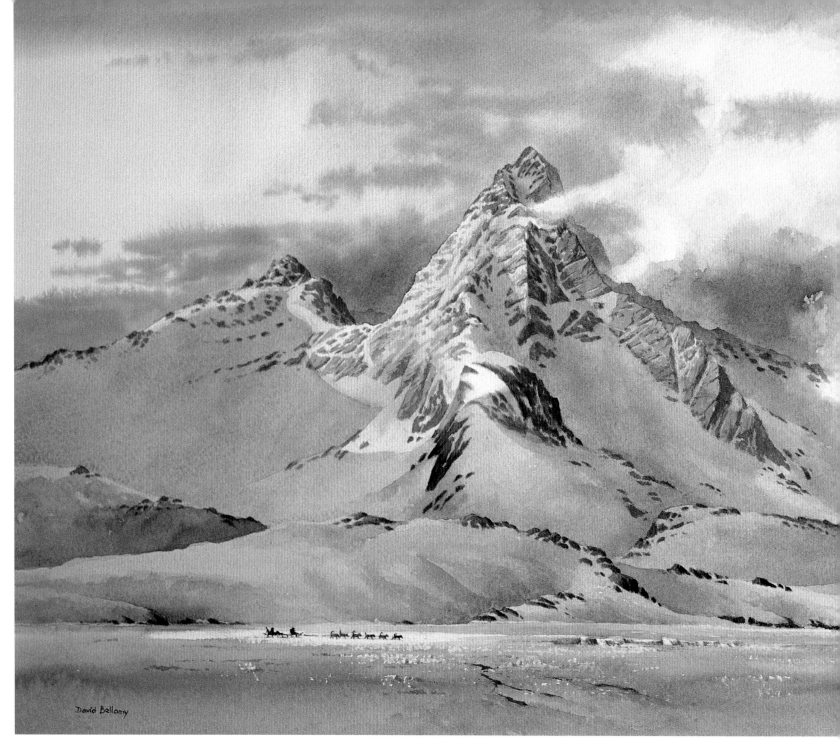

David Bellamy

CROSSING SEA ICE, GREENLAND
31 x 48 cm (12 x 19 in)

Vast areas of snow pose a trap for the unwary artist, especially in flat lighting. Yes, we need white highlights, but in order to make them stand out we also need shadow areas, as well as showing up the contours formed by ridges, gullies, slopes and shadows caused by cloud. The problem can be further complicated by low white clouds, as in this case. The other danger with such huge fields of snow is the need to introduce warm colour to counter the overwhelming cold look of the scene. The sky, crags on Qimmeertaajallip Qaqqartivaa caught in sunshine, and huskies, work well to reduce the coldness here, and often reflections in water can be put to good effect for this purpose. Note how the crack in the foreground ice leads in towards the huskies and sledge.

Working in the Arctic

Expeditions in the Arctic, though intensely cold, can be done on dog-sledges, covering around 60 kilometres (40 miles) a day, including many sketching stops. Duvet jackets and several layers of thermal clothing are the order of the day, and extra-warm headgear is vital. Just an ordinary woollen hat is simply not good enough in the Arctic winter. I had three hats on at one stage while crossing pack ice and was still too cold! Several pairs of gloves give flexibility, including a thin pair for sketching. Tinted goggles are essential, preferably grey to avoid colour bias.

Working in a water-based medium can be problematic, even when mixing copious amounts of gin in the painting water to act as an anti-freeze; in really low temperatures it can still ice up quickly and brushes become miniature spears. In really bad conditions I carry a 'cod-pack' – a neoprene pencil case containing watersoluble pencils and an Aquash brush with water in the handle. This is kept inside my trousers for warmth and, when in use, by covering up the handle of the brush with my hand to keep it warm, it can be worked fairly effectively.

Other ways of creating colour sketches in severely cold temperatures are by using coloured pencils or watercolour pencils laid dry on the paper. In the evening in hut or tent these can be washed over with a wet brush, best done while the image memory is still clear in the mind. It is always worth making colour notes if working in monochrome, especially where the colours are unfamiliar.

Working below zero

MALGRUBENSPITZE, AUSTRIA (LEFT)
This original sketch was made on cartridge paper in freezing conditions as the winter evening approached, on a ridge in deep snow, which helped to stop me sliding down the steep slope. The reticulations caused by the icing up of the washes are clearly visible.

DOG-SLEDGE AND ICEBERGS (RIGHT)
22 x 33 cm (9 x 13 in)

Here Eskimo Fred is driving Torben, my Danish friend who had joined me on this Arctic trip, across a frozen fjord in light misty conditions with huge icebergs frozen into the surface ice looming up in great white towers. Unfortunately, I lost their sledge for some time when Fred's dog team charged off into a side valley, and went round in circles for a while.

YMERS BERG RANGE, AMMASSALIK (RIGHT)
One way of coping with intense Arctic cold, where watercolour washes freeze instantly no matter how much gin you use (in the painting water!), as in this case, is to work in pencil. Here I laid pencil hatching to denote dark tones. Later, back at base I laid on colours indoors. Making colour notes on the spot is invaluable with this manner of working, but here I did not need any. Had I scribbled across the paper, covering it completely, any subsequent watercolour washes would be resisted by the dense pencil mass, so hatching is the most effective method.

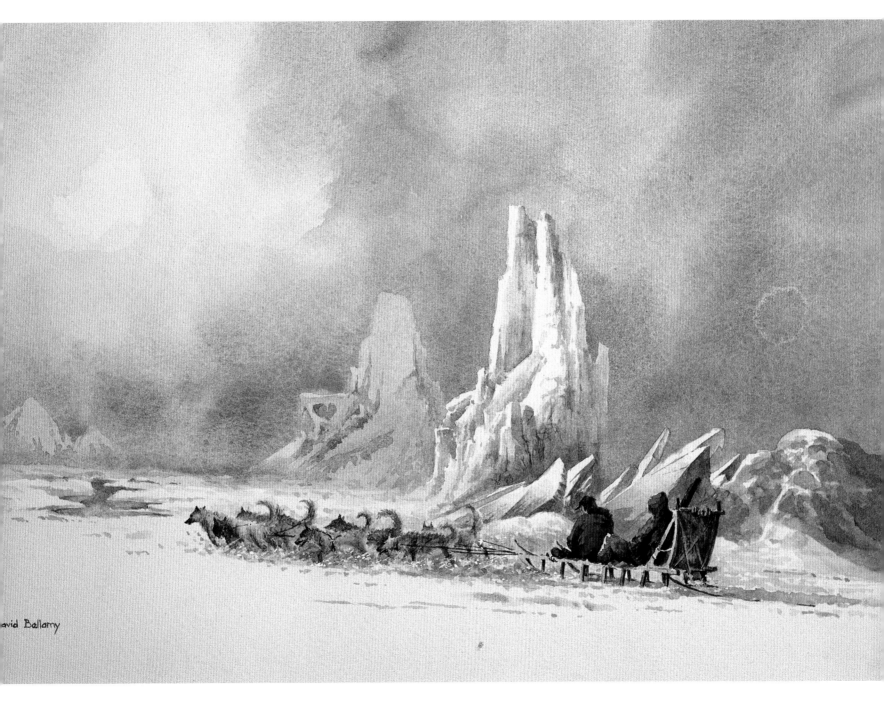

David Bellamy

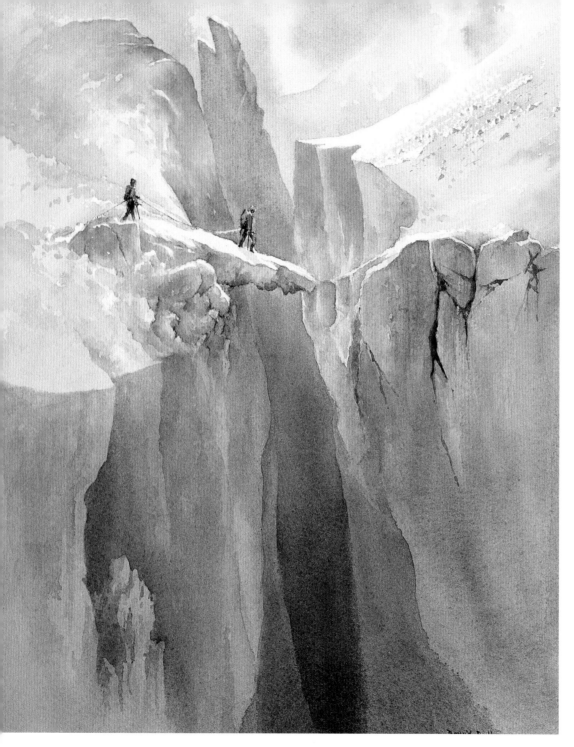

Glaciers

If you enjoy painting snow and ice formations, do not ignore glaciers. There is more colour in ice than many people realize – subtle effects that can be emphasized by creative lighting. This colour is particularly striking when inside glacier ice or down crevasses.

Abseiling into crevasses is not on everyone's must-do list, but such dubious subjects as snow and ice bridges or unstable séracs can provide unusual and dramatic compositions. This is, of course, only for those who have had experience of ice-climbing. Make sure all your sketching gear is well secured, especially sketchbooks. Icefalls are particularly dangerous from collapsing ice towers and boulders hurtling off the moving ice like cannonballs. Icefalls are often best seen when light mist wafts in and out of the contours and sunlight gleams on stark ice. Glaciers can be painted for their own features, or as foregrounds to mountains.

FALLEN ICE BLOCK, SVINAFELLSJOKULL GLACIER (LEFT)
33 x 21.5 cm (13 x 8½ in)

Glaciers are cold, hostile places, but look carefully and you will find incredible beauty in the ice in fascinating shapes, colours and tones. Crevasses, of course, are the stuff of nightmares, as in this scene on one of the vast Icelandic glaciers. Most of it was painted with tones of Pthalo Blue (Green Shade).

SERACS ON THE ICE-FALL, ARGIETIERE GLACIER (RIGHT)
33 x 50.5 cm (13 x 20 in)

Spending any time on a glacial icefall is suicidal madness, as they are completely unstable. The broken ice towers are likely to collapse at any moment and much debris flies off the moving mass of ice, mainly boulders as well as blocks of ice. Davy's Grey formed the main colour base here. The figures intensify the sense of savagery and make the séracs appear huge by comparison. To the eye jaded by the monotony of serried ranks of savage ice towers, swirling mist provides welcome relief. One can have too much excitement.

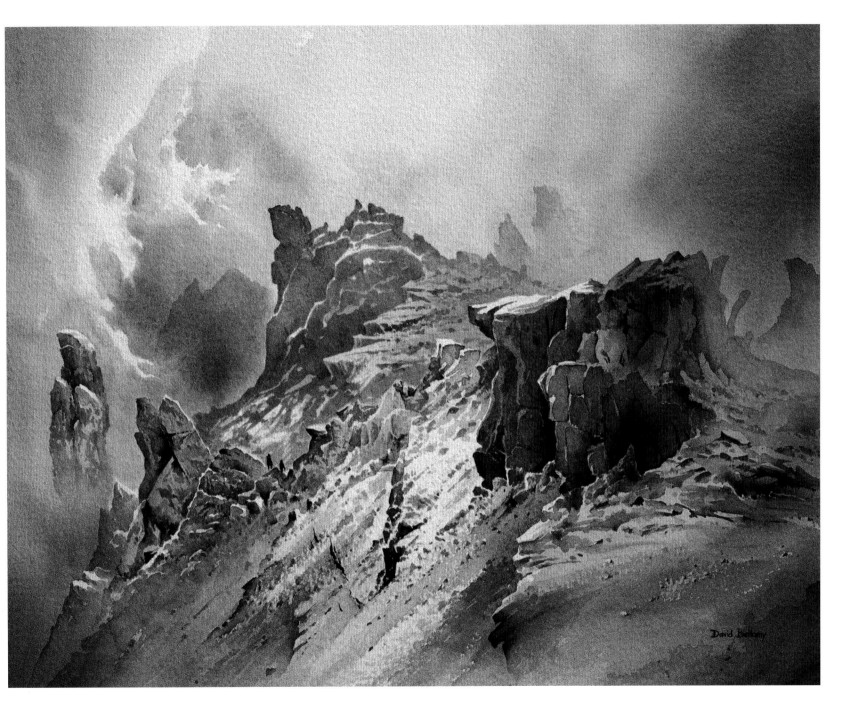

DEMONSTRATION:
STONETHWAITE BECK, CUMBRIA
31.5 x 23 cm (12½ x 9 in)

Wet-in-wet misty backgrounds portray a sense of mood as well as hiding great amounts of background detail, and are an effective weapon in the watercolourist's armoury. Here we look at the treatment of misty fells and autumn trees.

Stage 1
The whole paper down as far as the top of the bridge was copiously wetted, and Cadmium Yellow Pale and some Cadmium Orange was applied to the birches. Naples Yellow was laid into the top right of the sky, then a pre-mixed wash of French Ultramarine and Light Red washed over the left area and down below the Naples Yellow, bringing it down to the trees. Then I rendered the darker parts with a stronger version of the same mixture to suggest the fellside and crags. Some Yellow Ochre was introduced in the lower slopes. Care had to be taken to avoid painting over the parts needed to be kept white.

Stage 2
Some of the sky mixture was painted under the bridge, together with splashes of Yellow Ochre, and parts above the bridge were sharpened to highlight the structure. Some of the tree foliage definition was improved by darkening the background in places.

Stage 3
I sharpened up more trees, keeping some edges soft by applying water first. On the walls and many rocks I applied a mix of Ultramarine and Cadmium Red, then dropped in touches of Yellow Ochre. The beck was rendered with the same mixture.

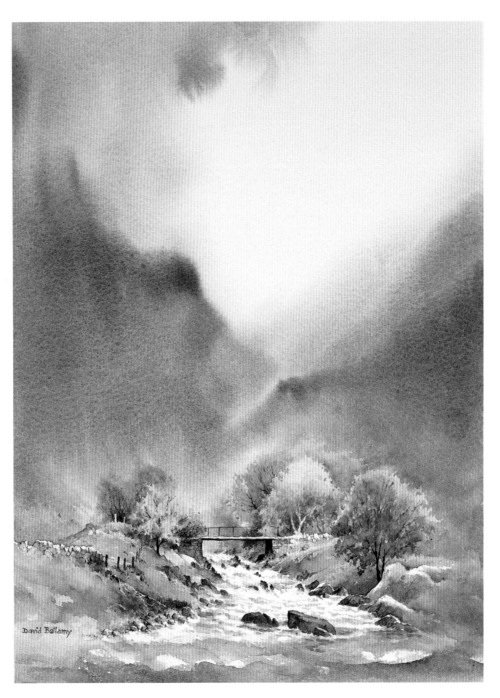

Stage 4 Finished painting
I strengthened the background behind the right-hand trees, then completed detail on the fence, trunks and other places. The rocks in the water and banks were defined more clearly and the water was finished.

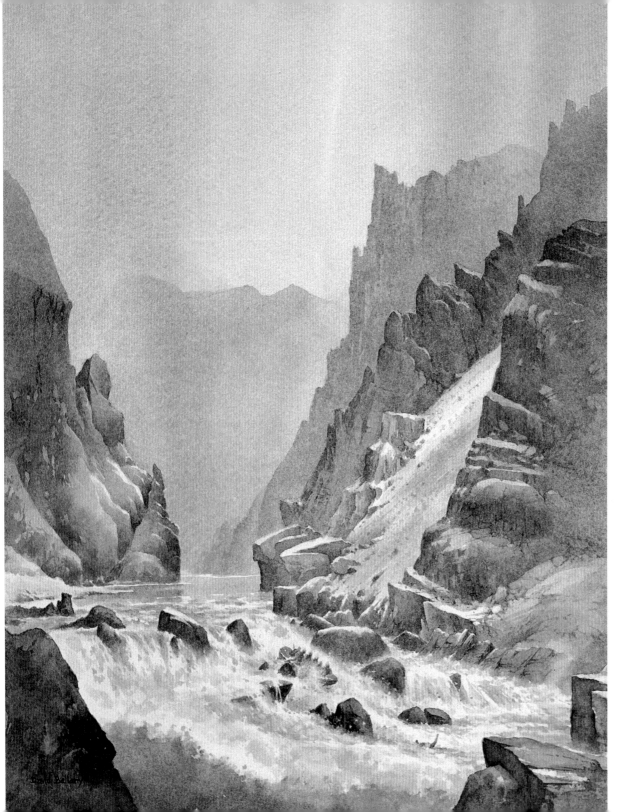

RAFTING DOWN THE INDUS
31 x 24 cm (12 x 9¹/₂ in)

Because of fine detail on the raft and figures I used Saunders Waterford hot-pressed paper. The painting depicts an incident that occurred as we shot down rapids between the soaring precipices where India butts up against Asia. Hazel was suddenly flung overboard and is seen here being swept away, while our raft was jammed in between rocks. I have left many soft edges where seething water rushes in front of rocks. This is another scene that illustrates how insignificant we are in such sublime scenery. Hazel was thankfully rescued by our second raft.

Sketching in canyons and caves

Working in wet, muddy environments and at times being totally immersed in these elements makes great demands on your equipment. Art gear is especially vulnerable and, unless well protected, it can emerge in absolute tatters. Ammunition boxes are robust, but heavy, and tackle sacks made for caving can work well in some locations, although you need further protection inside, including a waterproof bag if there is any prospect of it getting wet. My preference is for the purpose-made Pelican boxes manufactured from heavy-duty plastic that are used mainly by the rescue services. Although expensive, these boxes are waterproof, fairly light and contain foam padding for cameras, and on a sling will happily follow you across an underground lake like a dog on a leash.

Inside the container at the top I keep a small towel with which to clean my hands before touching sketching gear or my camera. Sketching gear is kept to a minimum – watersoluble pencils, plus ordinary pencils, charcoal, a brush or two, including an Aquash brush, and conté crayons. I carry one, or at most two, sketchbooks or sketching folders – larger sketching paper needs to be kept in a tackle sack or rolled up in a sturdy plastic art tube available from certain art shops.

I make a point of attaching the Pelican box to my belt with a quick-release karabiner, as I was once trapped in an underwater pothole in a streamway. Supplementary lighting can be extremely useful and I sometimes take a submersible torch.

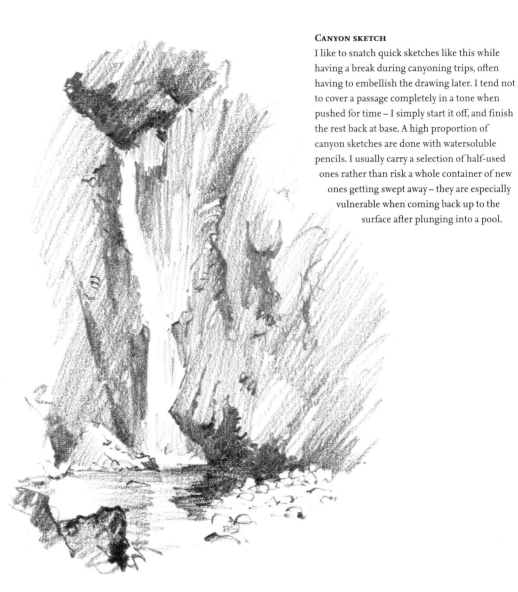

CANYON SKETCH
I like to snatch quick sketches like this while having a break during canyoning trips, often having to embellish the drawing later. I tend not to cover a passage completely in a tone when pushed for time – I simply start it off, and finish the rest back at base. A high proportion of canyon sketches are done with watersoluble pencils. I usually carry a selection of half-used ones rather than risk a whole container of new ones getting swept away – they are especially vulnerable when coming back up to the surface after plunging into a pool.

Gorges and canyons

These range from steep-sided valleys to narrow defiles similar to a cave without the roof. Sometimes rafting or canoeing is necessary to reach an area. Canoes make unstable sketching platforms, so normally I try to land on shore or a large rock to render a scene. Trying to sketch and control the canoe at the same time can be a little over-ambitious. Rafts are more stable and in reasonably calm water when you are not paddling it is easier to capture quick images of a scene.

Watersoluble pencils come into their own when working on rafts or canoes. Equipment should be kept to a minimum. Waterproof disposable cameras can be valuable for these trips and save you risking your expensive camera. There is an excellent selection of waterproof boxes and dry-sacks available, if you are really serious. If you are relying on plastic bags, double wrap everything, though even then, on a wild, wet trip this wrapping is unlikely to keep the water out for long.

Some gorges are too narrow for canoe and raft access, and also feature huge waterfalls, so the only answer is canyoning in a wetsuit. This sport demands a mixture of essential climbing and aquatic equipment.

You also need good knowledge of the route. Do not attempt such a venture without an experienced colleague. Long abseils down waterfalls can test most of us, and we need to be confident that we can make it to the far end. When Catherine launched herself eighty feet down a vertical cliff into a deep black pool in a Spanish canyon it tested my nerves far more than hers. On that trip my art materials container exploded when it hit the surface at speed, spewing pencils and brushes in all directions, but I still managed several sketches. The light in the gorge, however, was so dark that the camera failed on most of the shots, so the sketches provided the only visual record.

The canyoning artist occasionally feels the need to sketch while totally immersed in deep water. Rather than tread water the optimum sketching position is to lie on your back using your legs to control position and movement, with your sketch paper on your chest. I tend to take a small plywood board with elastic bands securing a number of pieces of loose paper. This method, of course, holds interesting potential for wet-in-wet techniques. Many procedures that apply to canyoning are similar in caving.

David sketching in Peak Cavern

MAASAI IN THE OLKARIEN GORGE, TANZANIA
32 x 45.5 cm (13 x 18 in)

This impressive gorge, the home of hundreds of
vultures, lies at the edge of the Great Rift Valley. The
Maasai warriors add colour and lend a sense of scale
to the painting to suggest the immense cliffs, where
the hordes of griffon vultures nest.

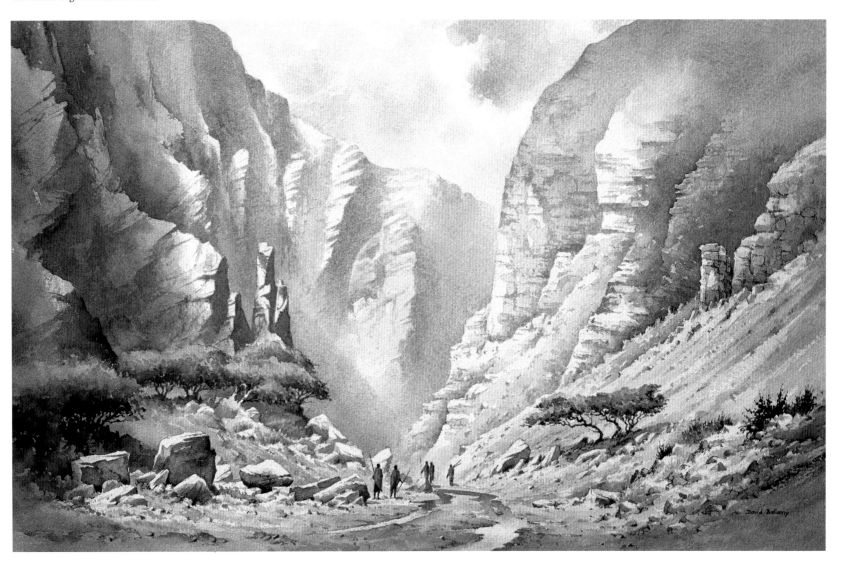

Descending Swinsto Hole, Yorkshire
25 x 16 cm (10 x 6 in)

This trip involved seven or eight abseils, pulling the rope down after us, so there was no way back up: we had to exit via the main river passage at the bottom, hoping it was not flooded. This sort of expedition adds an agreeable liveliness to one's sketching. Needless to say, all sketching gear had to be kept in a waterproof box. I sprayed the wet wash depicting the waterfall to soften the effect, especially the edge.

Caving

Not all caves are difficult or dangerous. There are many where you can walk in and explore some way – though always ensure you have a head-torch, a helmet and a companion who knows what he or she is doing. Caving images can be stunning, especially when the subject is backlit. Usually the best caving pictures involve the caver as much as the cave itself, for the figure

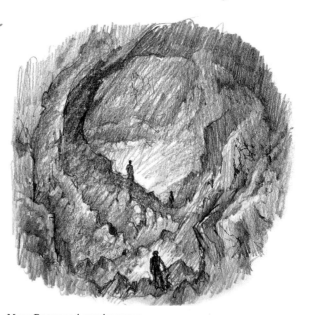

Andrew Zerbino climbing in Ogof Ffynnon Ddu
Andrew posed for this sketch and in the dim lower light I blended his legs into the rock face, making him seem to be part of the rock wall. While this was encouraged by the mud on his lower overall being the same colour as the rock, it is a useful method of achieving a sense of unity.

Main Passage, Agen Allwedd
Underground you can arrange the lighting according to your needs, within reason. In this sketch I took advantage of cavers' head-torches to play light in strategic points of the scene. As it takes time to wind your way in the dark through boulder-passages such as this, I had time to sketch a figure in one position, then capture it again further along when it was in a position I liked. No doubt two of these figures are the same person! Obviously this procedure only applies in enormous caverns like this. With the highest caver I watched for a while as his torch ranged across the walls and roofs, then put in some faint illuminated detail before rendering him. In a painting of this I would subdue two of the figures, simply suggesting them so that the focal point becomes the third, close to which I would create stronger detail in the cave topography.

immediately becomes a centre of interest and provides a sense of scale. Cavers moving towards you down a streamway can be especially evocative, as their head-torches move to create flashes of light ricocheting off water, wet rock and other bodies, although this is quite challenging to capture. I often carry supplementary lights to place in strategic positions. Working with a photographer can be interesting; often it takes longer to set up for underground photography than it does to carry out the sketch.

Occasionally I sketch caves in watercolour, but I normally prefer to use a variety of pencils, charcoal and conté crayon, charcoal being quick to render a scene. Speed is essential when drawing the moving figure. Having a model is a boon, but the best images usually come when a caver is passing through a difficult or dangerous place, with their body momentarily exerting a dynamic posture before moving on. Try to persuade the caver to move in slow motion, or even stop or pause in the crux position. Waiting in such locations for people to come through can yield striking images.

Caving does have its lighter moments, too. On one trip into a dire Derbyshire cave, while sketching crouched in an extremely narrow streamway,

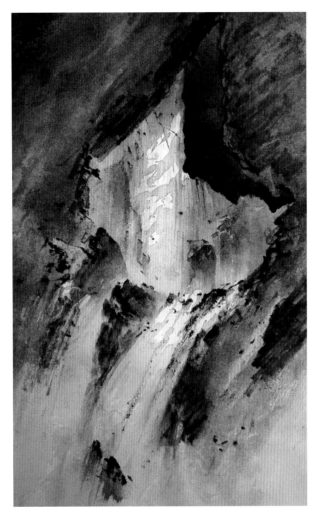

members of a ladies' caving club came along, and relieved the gloom by scrambling all over me.

The natural world is full of incredible places of priceless beauty, in many of which we have to overcome hazards and obstacles before even thinking about turning them into pictures. Many will always enjoy the buzz of getting there, and the pleasures of taking back sketches and paintings carried out in such savage terrain will be with them all their lives.

UNDERGROUND CASCADE SKETCH I (LEFT)
Without any figures there is no idea of the size of the cascade or rocks.

UNDERGROUND CASCADE SKETCH II (BELOW)
Here the addition of the caver illustrates the generous proportions of the chamber.

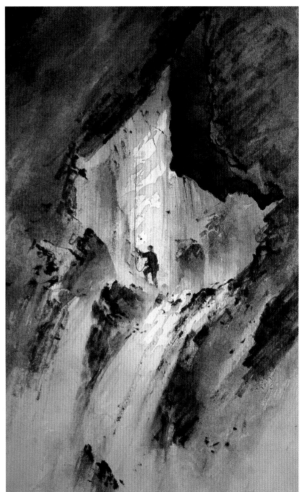

DEMONSTRATION:

Aiguilles de Bavella

25 x 35 cm (10 x 14 in)

We tend to paint the sky first, then more or less work our way down the paper, but here the light pinnacles demand otherwise. In this demonstration I show how to paint a two-stage sky with an overall moody feel to the scene.

Stage 1

I began by laying Naples Yellow, Yellow Ochre and Cadmium Red on the four main spires, then some French Ultramarine mixed with Cadmium Red. On the lower slopes I painted Naples Yellow and splashes of Yellow Ochre.

Stage 2

I mixed a deep pool of French Ultramarine and Cadmium Red , then used a large mop to bring this down over the sky, carefully avoiding the pinnacles and leaving white spaces for wispy clouds – these spaces were quite a bit larger than can be seen here. While this was still wet, I softened off the edges of the clouds in places with a damp No. 6 sable brush. This action, and the creeping sky wash, reduced the white clouds to what you now see. The strength of the wash was varied in places.

Stage 3

With a slightly stronger version of the sky wash, I laid colour to define the light grey cloud mass above the lower white space, fading into the upper sky. Darker washes were placed next to some of the pinnacles and to render some of the darker pinnacles. On some of the closer crags Yellow Ochre and Cadmium Orange were dropped in separately. I used more of the sky wash to cover the background left-hand peaks and to suggest some vague detail on the far right. A certain amount of detail was drawn into the pinnacles and lower crags using a rigger.

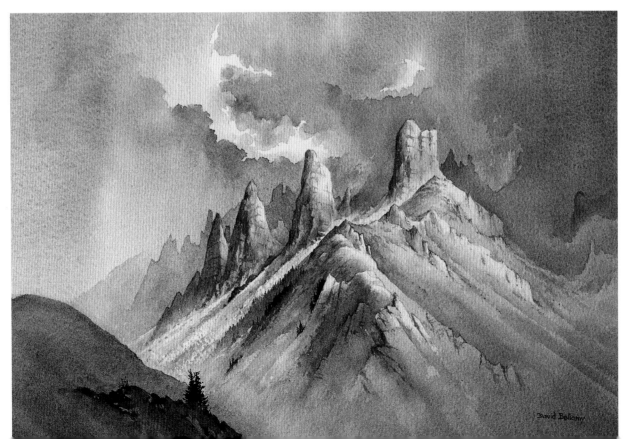

Stage 4 Finished painting

More detail was applied to the pinnacles and the wooded slopes rendered with a small mop brush. A few more trees were added and, finally, some detail to the foreground.

Breaking up hard edges

Refugio Alberto

Have a go at painting the view in this photograph of the Vajolet Towers in the Dolomites, but try to introduce some atmosphere to soften and break up some of the hard edges. A little colour variation would also help. Would this work best as a vertical format or as it stands? Think about altering some of the lighting and shade effects. My painting is on page 125.

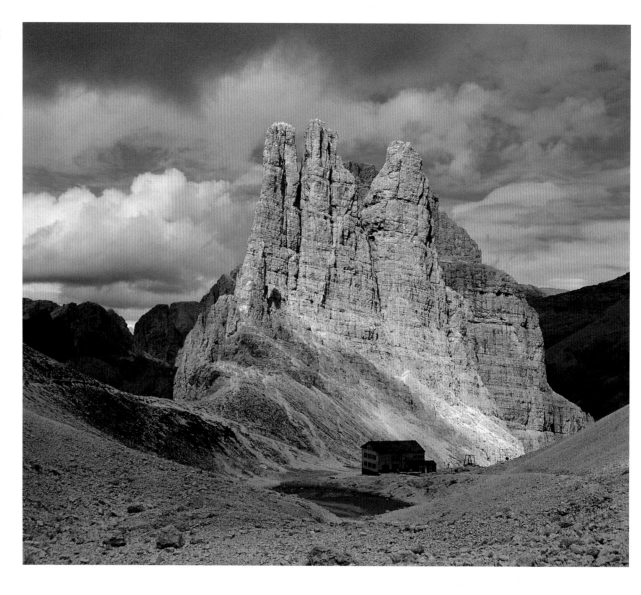

Tackling an epic view

Grand Canyon of Yellowstone

This view was first made famous by the artist Thomas Moran (1837–1926). Of course, you can just paint a section of the photograph, as it is something of an epic scene. Much detail can be eliminated by atmosphere and shadow, and do not forget to lose some of those razor-sharp edges. It would be a good idea to make a thumbnail sketch or two first. My own attempt is on pages 126–7.

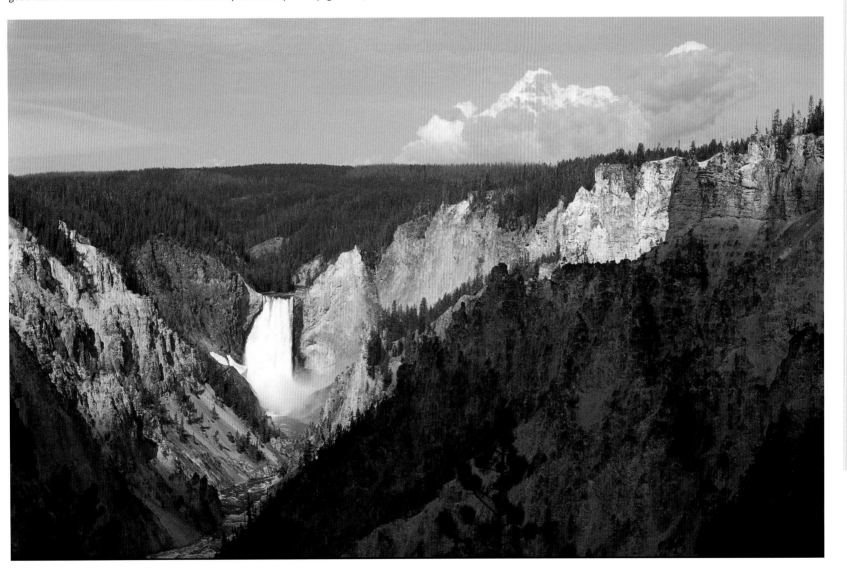

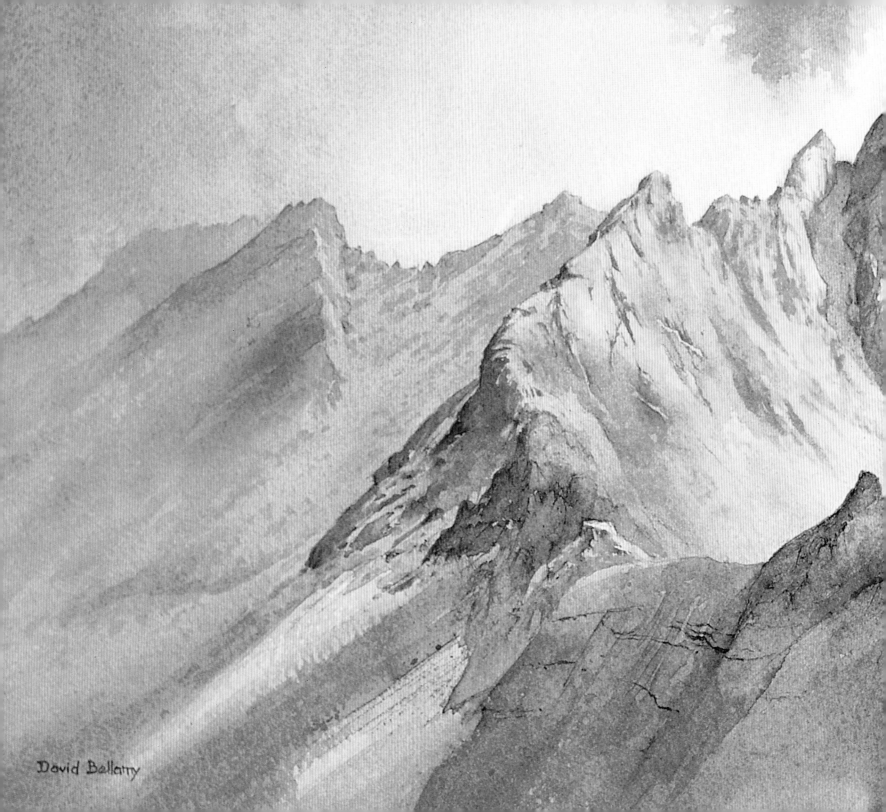

David Bellamy

8
Gallery of Paintings

In this final chapter we look at the paintings I have done in response to each of the exercises in foregoing chapters. They are simply one interpretation of the scene, and not presented as the ideal answer. On another day I might feel completely different about the approach to the same scene, and end up with a dramatically different result. If your painting is completely different that is fine, as the object is to stimulate creative energies. It is best if you only examine these paintings after producing your own version, then perhaps have another go at it.

Changing colours

Sgurr Alasdair, Isle of Skye
29 x 46 cm (11 x 18 in)

I subdued the left-hand Cuillin ridge as it recedes, simply suggesting detail. When the initial sky wash had dried I scrubbed on the clouds using the side of a No. 10 sable brush, and as this was painted on Waterford rough-surface paper the edges appear quite ragged. These mountains are highly reflective and change colour rapidly in strong light, so I exaggerated the warm light catching the peaks around Coire Lagan. The lightest part of the central area comes up against the darker steep ridge ascending to An Stac and the almost completely obliterated Innaccessible Pinnacle. I left out the foreground ridge. Note the two climbers below An Stac.

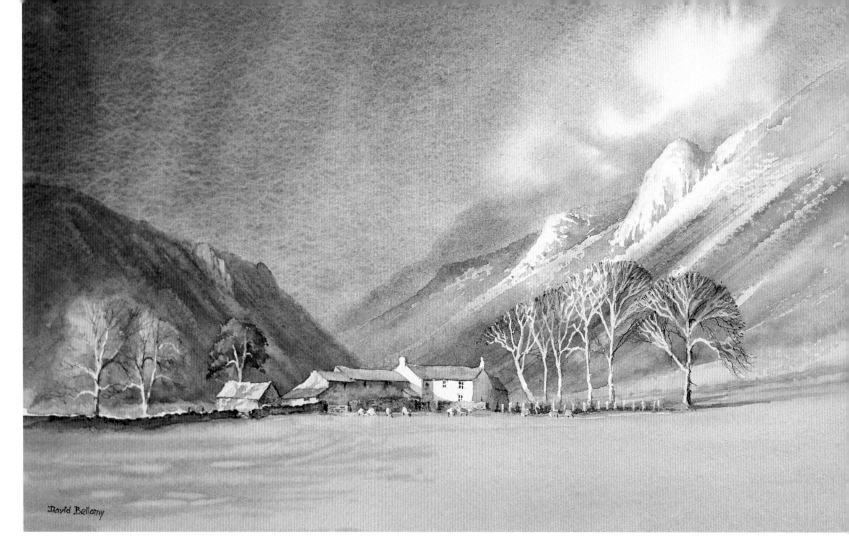

Painting a farm

BROTHERILKELD FARM, ESKDALE
21 x 30 cm (8 x 12 in)

This scene has been rendered much as I saw it, without great alterations, even with the atmosphere. The small sheep are barely distinguishable. I used masking fluid for the light trunks and branches, fence posts, sheep and the white parts of the house.

Simplifying the background

SKIDDAW AND DERWENTWATER
21 x 30 cm (8 x 12 in)

This is an exercise in simplification, so I had to resist the urge to put more detail on the rocks and closer trees. The background mountainsides were deliberately laid on with hardly any detail, simply suggesting a few gullies. In order to make the central crag and trees stand out as the focal point I painted bright Cadmium Yellow Pale on the far shore where it abuts these features. The light slivers across the placid water were created with a damp 12 mm ($\frac{1}{2}$ in) flat brush; the lower sliver was extended a little to the left with a scalpel when the paper had dried.

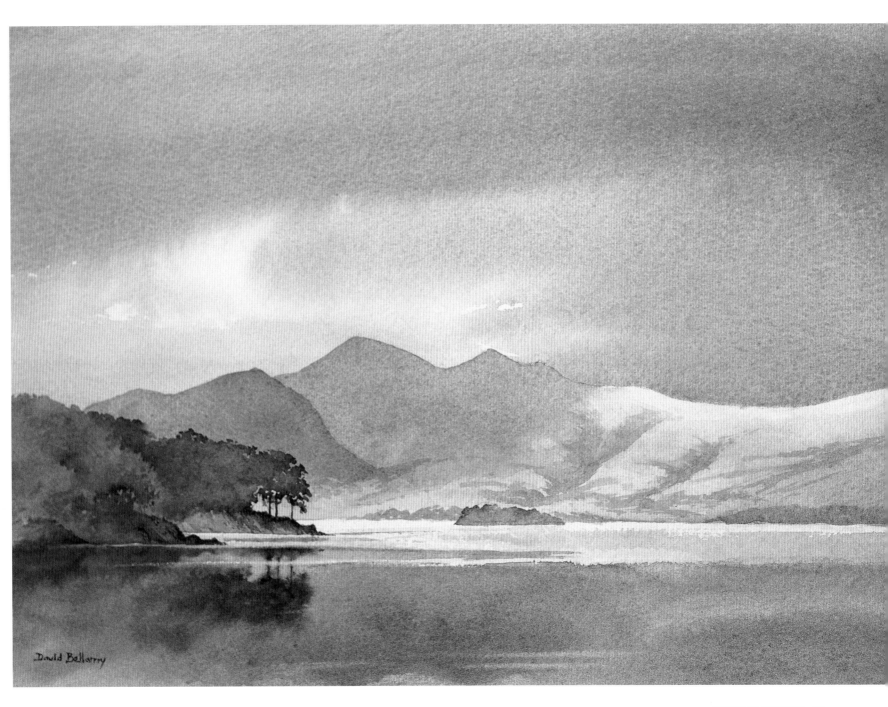

David Bellamy

Manipulating shadows

OLD PALACE, LEH
24 x 34 cm (9 x 13 in)

The buildings stand out strongly against the brilliant white snow on the Ladakh range, but I have lightened them somewhat in order to more detail. Cloud shadows can be moved to suit your needs, of course, and I usually accomplish this by covering the paper with a wash of clean water, then dropping in the shadow colour, in this case French Ultramarine and Cadmium Red.

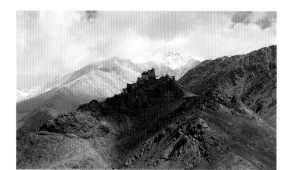

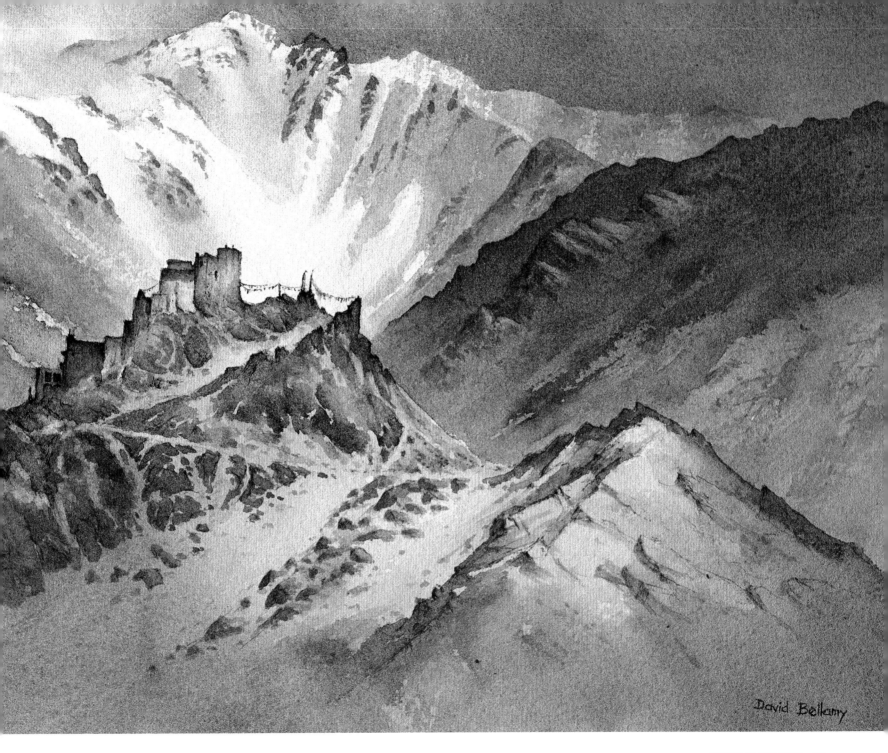

David Bellamy

Being selective

FARM BELOW CADAIR IDRIS

22 x 27.5 cm (9 x 11 in)

Yes, the resulting painting is quite different from the original view on which I have based it. The large house, telegraph poles and most of the rough slopes have gone, a road, figures and tractor added and the whole brought together a bit more. I did, however, paint a faithful rendering of the wonky tractor exhaust from a photograph I had taken earlier. Sometimes I see just a part of something that excites me – perhaps just a chimney – and make up the rest.

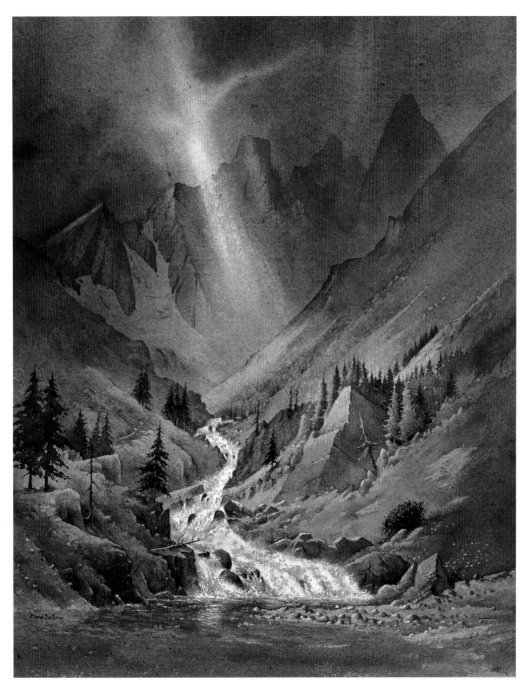

Emphasizing mood

STORM OVER THE VIGNEMALE

42 x 31 cm (16½ x 12 in)

This painting was done on Blue Lake tinted paper, and I brought out the highlights with white gouache. The background cirque of peaks is subdued by the dark stormy atmosphere, with more light thrown onto the closer crags. The tree cover has been thinned considerably to allow the viewer easier access to the upper reaches of the Gaube Valley, helped by a faint path on the left. I have made the river continuous, as a lead-in for the viewer.

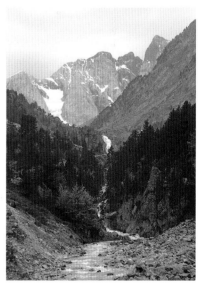

Focusing on the important features

Scwd Cil Heptse, Brecon Beacons
43 x 30 cm (17 x 12 in)

I chose a vertical format for this painting, as this emphasizes drama, and in this case fits with the composition. The upper part of the scene was lit by weak, but warm, dying January sunlight, so I strengthened this, even though it is the most distant part of the scene. Despite having much detail eliminated, this painting is still rather busy. As the features get closer to the foreground stronger texture and detail is apparent. A fan sable brush enabled me to achieve some of the falling water effects.

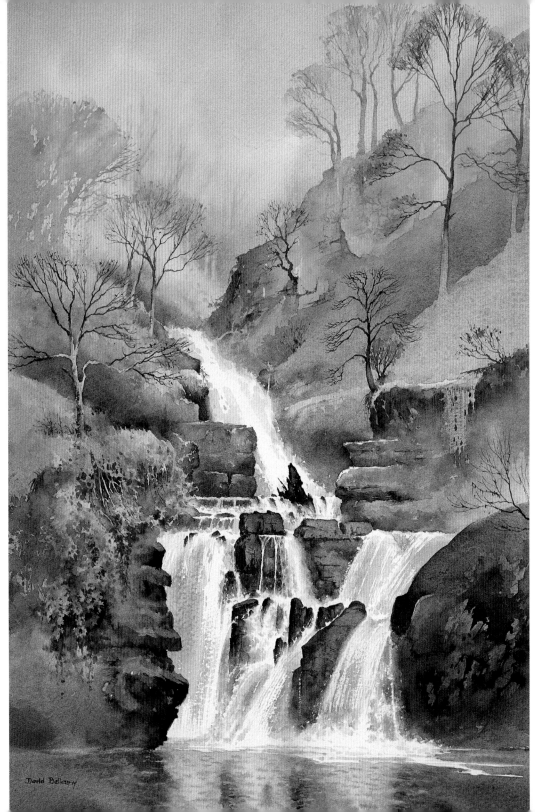

David Bellamy

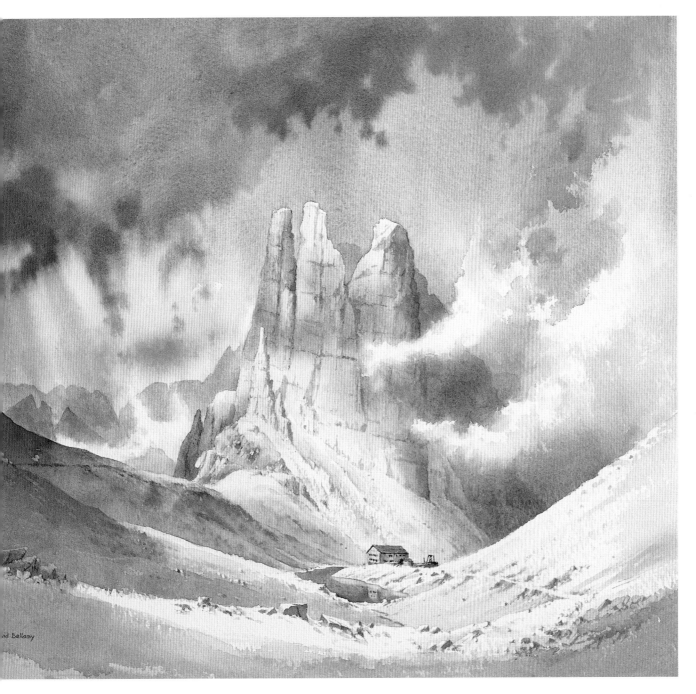

Breaking up hard edges

REFUGIO ALBERTO AND THE VAJOLET TOWERS
35 x 40 cm (14 x 16 in)

I added some warmth in the left-hand sky to balance the otherwise cold scene. The warm grey colour was achieved with French Ultramarine and Cadmium Red, with a series of varying tones of this mixture employed in defining the cloud-streams coming in from the right to break up the vertical faces. Although the refuge is in fact an enormous place that accommodates hundreds of alpinists, it is dwarfed by the massive towers of Dolomitic limestone.

Tackling an epic view

GRAND CANYON OF YELLOWSTONE, WYOMING

31 x 51.5 cm (12 x 20 in)

This extremely complicated scene sets quite a challenge, especially to the watercolourist, who cannot afford to make many mistakes. Most of the various sections have been underplayed to some degree so as not to overwhelm the scene with detail. Much of the background is lost in atmospheric weather closing in, relieved only by some Naples Yellow in the left-hand sky. Much Naples Yellow has been used on the golden cliffs, together with Yellow Ochre, and I have tried to reduce the harsh contrasts in the original photograph, caused by strong variations of light and shadow.

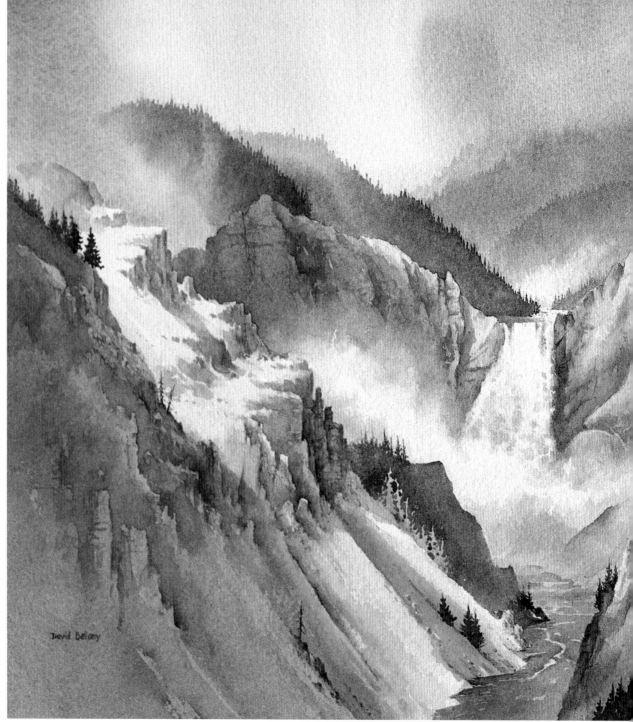

Index